#1

Author:

EMMI SALONEN

MW01102466

COMMON INTEREST: DOCUMENTS

Design and format solutions for the arts, culture, academia and charities

COMMON INTEREST:
DOCUMENTS

Published by:
Index Book, S.L.
Consell de Cent 160 local 3
08015 Barcelona
Spain
T: +34 934 545 547
F: +34 934 548 438
ib@indexbook.com
www.indexbook.com

Copyright 2010 © Index Book, S.L.

Publisher:
Sylvie Estrada

Author and Art Director:
Emmi Salonen

Design:
Studio EMMI
www.emmi.co.uk

ISBN: 978-84-92643-53-0

Author:

EMMI SALONEN

COMMON INTEREST: DOCUMENTS

Design and format solutions for the arts, culture, academia and charities

Contents:

<u>Introduction:</u>

DESIGN AND THE COMMON GOOD

This book showcases document designs, including leaflets, brochures and books, designed for organisations that exist to provide a positive experience through learning, creating an event or providing a structure for the individual to better themselves. The chapters are organised by sector; academia, art, charity and culture, highlighting how even within the showcased fields the works are very varied. For many of these documents environmental considerations are an integral part of the design and the production process.

 The common element of the sectors featured here is the need to appeal to a wide and varied public, so the designs must be attractive across the board. Eliminating exclusivity makes them 'open for all' and the experience becomes a shared one. The documents are also often made to be physically accessible by all, due to their distribution throughout public spaces, cultural events and galleries.

 From a designer's point of view, laying out a book or brochure requires thinking in sequences – something that only serves to make these documents more compelling. Printed work often has a short life, existing only for the duration of the event or an exhibition. If the document is beautifully crafted, however, it can become collectable and

people want to hold on to them as ephemera or inspiration. Some books may even become heirlooms – kept and passed down through generations.

In most cases designers aren't only concerned about the visuals but are also required to operate within a limited budget. Budget considerations can become part of the design solution as illustrated later on in the book.

In addition, this book attempts to provide guidance for designers through the working process, showing common paper sizes, formats and information on preparing work for print. These are meant as suggestions only and each designer should add and alter them as they see fit. *Common Interest* aims to inspire new thinking throughout the creative process and to open the way for unique and groundbreaking ideas and designs for the future.

Environment:

COMMON INTEREST: ENVIRONMENT

As designers and commissioners of design, we can make environmental considerations a vital part of the design process. It is not always possible to make each design 100 per cent environmentally sound, but we can aim to do our best. This book showcases many design solutions that have reduced their environmental impact beyond the given brief. At the back of the book, there is also a list of environmental considerations to keep in mind throughout the design process. p. 185

Often the first thing that comes to mind when thinking about sustainable design is recycled paper. Specifying environmentally friendly paper is certainly a good start. There are multiple paper options to choose from, ranging from recycled paper with various percentages of recycled fibre, to those where the energy came from to create the paper has been considered (some use wind power), as well as the amount of water and emissions involved in the process. A recycled paper that is certified by the Forest Stewardship Council (FSC) is always a good environmental choice.

Choice is the key word in the environmental discussion, whether that relates to specifying items for print or to the general running of a studio. Some green options are more environmentally friendly than others.

Before making any selections it is important to look at all the available options. Some companies choose to reduce their carbon footprint, some limit their use of resources and others are focused towards providing more sustainably sourced alternatives. It is not always possible to cover all the areas and use a product or service that meets the top marks on all, so the best advice is to research carefully and decide what matters the most to you when selecting material, choosing a printer and setting up your studio space.

 Common Interest includes case studies that are examples of efficient print solutions and production processes, such as using vegetable-based inks or incorporating attractive alternatives to finishings like foil blocking (which may make the final item unrecyclable due to not breaking down during the de-inking process). In some cases literature is designed in a way that it can be updated easily, reducing the need to printing new copies whenever changes are required, thus reducing costs and use of resources.

 This book serves as a brief introduction to the subject with the hope that it might inspire designers to consider more environmentally friendly design solutions and practices, while encouraging those studios that already do to carry on.

Format:

COMMON PAPER SIZES

There are real benefits for checking the sheet size of the paper you have chosen to use, and finding out from your printer what press size they are using. Maximising the use of paper can have a real effect on reducing waste in the production and could mean extra copies for the same cost.

Papers come in many size categories but the most common one is the ISO paper system, as seen on the right. ISO paper sizes are derived from an Ao size rectangle, which has the area of one square meter. In other words, the width and the height of a page relate to each other like the side and the diagonal of a square. There are a number of different paper 'series' that use the ISO system for determining sizes:

1. A-sizes are used to define the finished paper size
2. B-sizes allow for oversized formats and are often used for posters for example
3. C-sizes are used for envelopes to match the A-series paper
4. RA-sizes are used by printers to allow grip on the printing press
5. SRA-sizes are used by printers to allow for both grip and bleed

COMMON FOLDS

Labels within diagram: A0, A1, A3, A2, A5, A4, A6

A SERIES (mm)

A0	841 x 1189
A1	594 x 841
A2	420 x 594
A3	297 x 420
A4	210 x 297
A5	148 x 210
A6	105 x 148

B SERIES (mm)

B0	1000 x 1414
B1	707 x 1000
B2	500 x 707
B3	353 x 500
B4	250 x 353
B5	176 x 250
B6	125 x 176

C SERIES (mm)

C2	458 x 648
C3	324 x 458
C4	229 x 324
C5	162 x 229
C6	114 x 162

RA SERIES (mm)

RA0	860 x 11220
RA1	610 x 860
RA2	430 x 610
RA3	305 x 430
RA4	215 x 305

SRA SERIES (mm)

SRA0	900 x 1280
SRA1	640 x 900
SRA2	450 x 640
SRA3	320 x 450
SRA4	125 x 320

STANDARD US ("/mm)

8.5" x 11"	216 x 280
17.5" x 22.5"	445 x 572
19" x 25"	483 x 635
23" x 29"	584 x 737
23" x 35"	584 x 889
24" x 36"	610 x 914
25" x 38"	635 x 965
35" x 45"	889 x 1143

Format:

COMMON FOLDS

Imaginative use of folds can bring a piece of print to life and could be used as an alternative design element to avoid less environmentally friendly solutions like non-recyclable foils or lamination.

There are some considerations to bear in mind when folding paper or board. It is advisable to fold the paper parallel with the grain of the paper, as this will fold more cleanly and easily. This also means that the paper is less likely to break or look ragged. It makes the turning of pages more smooth and natural in feel.

A paper's grain is the direction in which most of the fibres lie. Paper can be either short or long grain, depending on how it is cut.

Paying attention to these details means you maximise both your paper and printing investments by avoiding costly reprints.

LONG GRAIN
The fibres run parallel to
the paper's long side.

SHORT GRAIN
The fibres run parallel to
the paper's short side.

Format:

SINGLE FOLD

Format:

SHORT FOLD

Format:

LETTER FOLD / C-FOLD

Format:

6-PAGE ACCORDION / Z-FOLD

Format:

8-PAGE ACCORDION

Format:

DOUBLE FOLD / DOUBLE PARALLEL FOLD

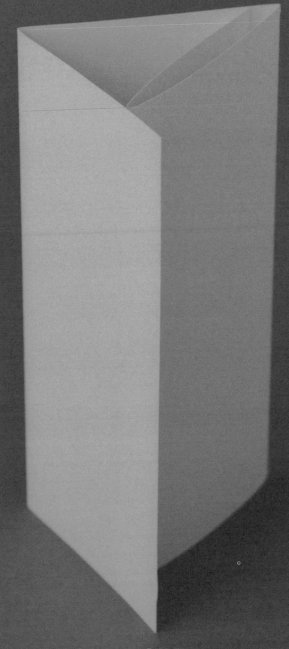

Format:

BARREL / ROLL FOLD

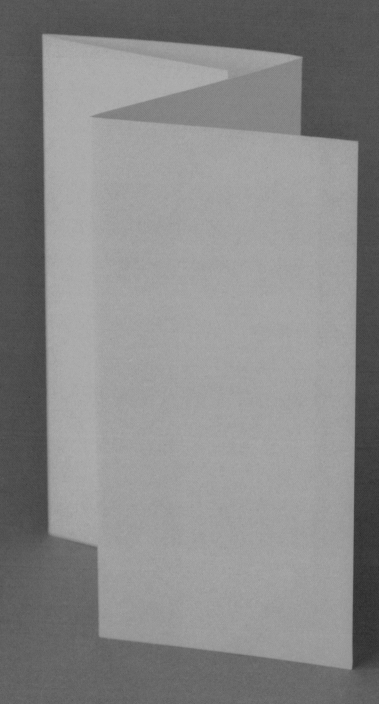

Format:

MAP FOLD

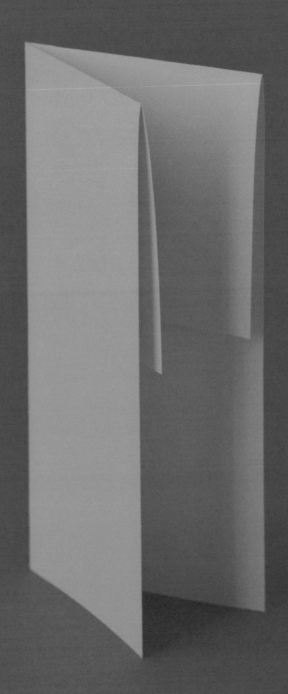

Format:

RIGHT ANGLE WITH SHORT FOLD

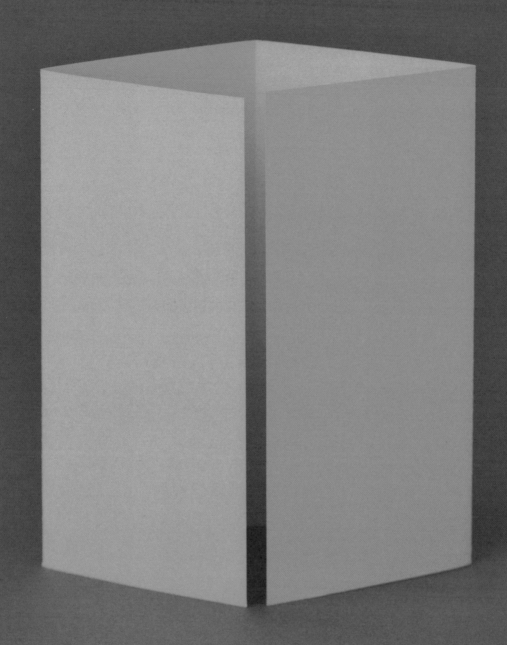

Format:

GATE FOLD

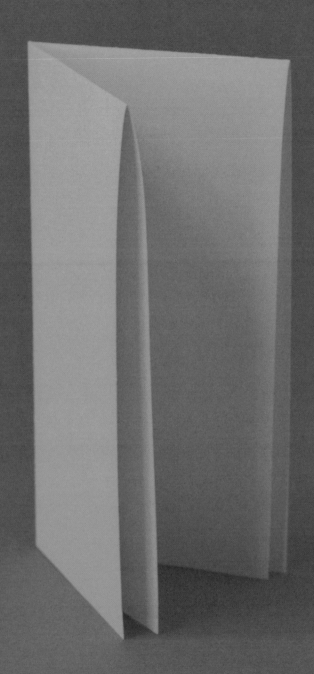

Format:

RIGHT ANGLE / FRENCH FOLD

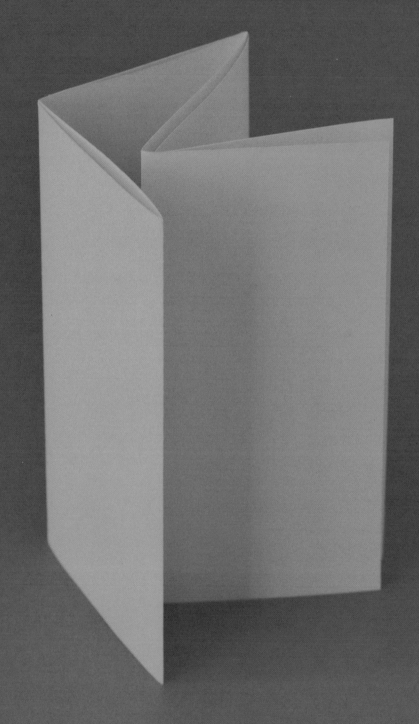

Format:

16-PAGE PARALLEL BOOKLET

Chapter One:

ACADEMIA

The case studies featured in this chapter are either created by a commissioned designer or designed in-house. In the latter examples, the team includes a group of students who worked on a project together with a tutor.

One example of collective work is 'Dear Lulu' by University of Applied Sciences of Darmstadt, Germany. Run by Professor Frank Philippin and designer James Goggin, 'Dear Lulu' is a testbook which was researched and produced by graphic design students during an intensive two-day workshop. The book's intention is to act as a calibration document for testing colour, pattern, format, texture and typography. Exercises in halftoning, point size, line, skin tone and cropping provide useful data for other designers and self-publishers to judge the possibilities and quality of online print on demand, specifically Lulu.com with this edition. p. 42

Print on demand is a good resource-saving alternative to printing in volumes, making it a desirable environmentally friendly method. Any book produced can also be offered for sale which makes it an ideal solution for individuals to make fanzines or books, for example.

This chapter features varied examples of how designers have created works for the academic sector, including many that are successful far beyond the initial requirements of the brief.

UNFOLDED **ZHDK, SWITZERLAND**

Title
Theaterpädagogik

Specifications
Size:
105mm x 148mm, folded
210mm x 297mm, flat
Colour & Print:
1-colour, offset
Folding:
A4 folded twice to A6

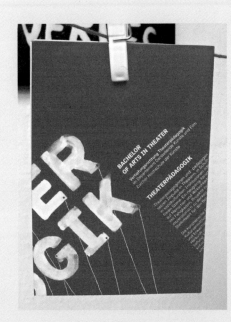

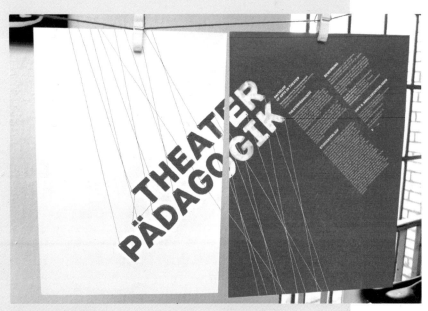

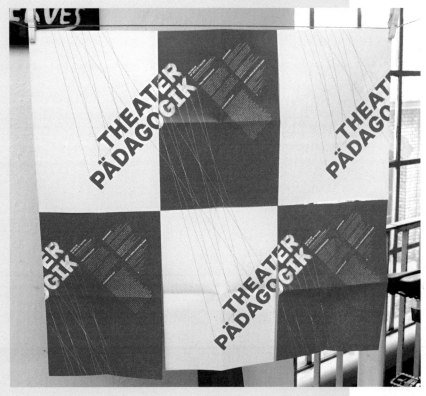

THE LUXURY OF PROTEST ROYAL COLLEGE OF ART, UK

Title
Research RCA Exhibition Catalogue

Specifications
Size:
105mm x 148mm, folded
313mm x 444mm, flat
Colour & Print:
1-colour (PMS Black), offset
Paper:
Arjo Wiggins Curious Metallics,
White Gold, 120gsm
Folding:
the piece folds down and tucks
into an A5 pamphlet
Finishing:
yellow-gold foil stamp

Information graphics by
Karin von Ompteda

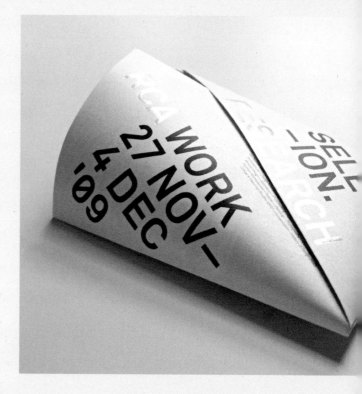

Finishing:

FOIL STAMP

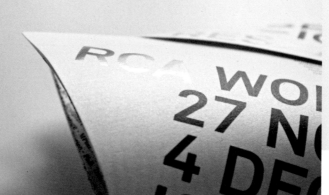

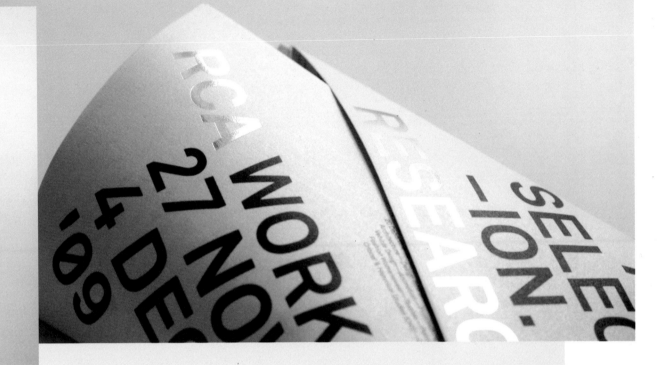
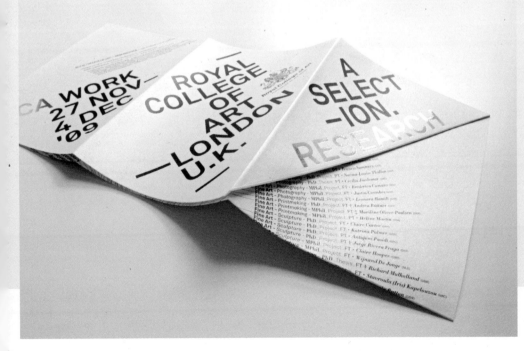

LA FABRICA DE DISEÑO **FAC. INFORMATION SCIENCES, UCM, SPAIN**

Title
Torán

Specifications
Size:
210mm x 240mm, 156 pages
with 8-page cover
Colour & Print:
2-colour, offset
Paper:
FEELme texturado, 300gsm
Binding:
section sewn
Finishing:
UV varnish

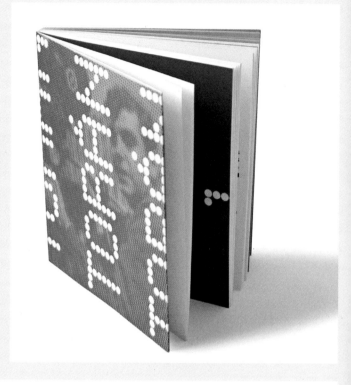

Format:

8-PAGE COVER

Title
Bachelor of Arts

Specifications
Size:
148mm x 210mm, folded
420mm x 594mm, flat
Colour & Print:
1-colour and CMYK, offset
Paper:
Lesebo Ivory 1.3, 80gsm

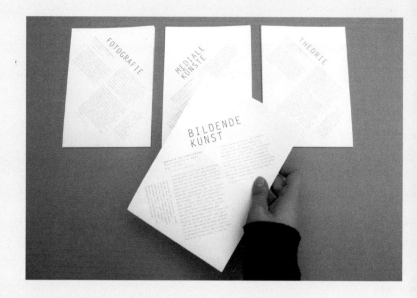

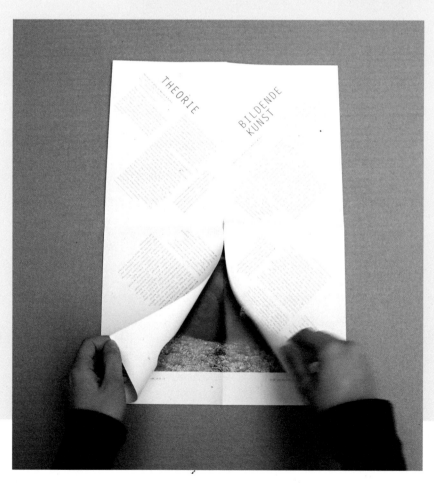

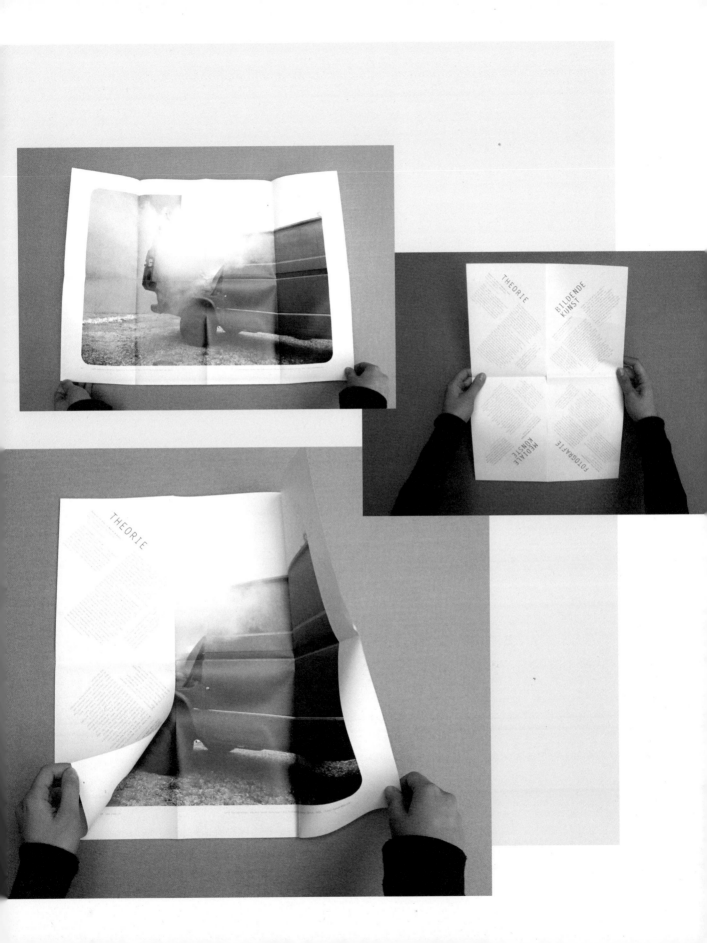

Title
5th Gimnazija Monograph

Specifications
Colour & Print:
2-colour, offset
Paper:
cover: Munken Polar, 300gsm
inner pages: Munken Polar, 120gsm
Binding:
perfect bind

This school monograph was
designed in the format of a
functional pencil case.

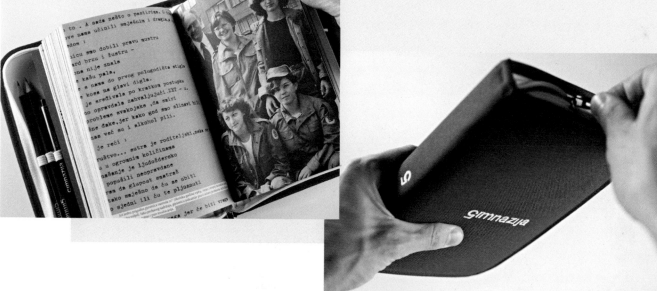

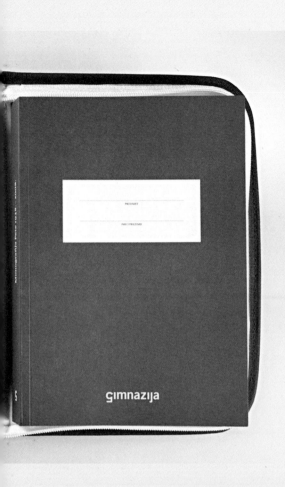

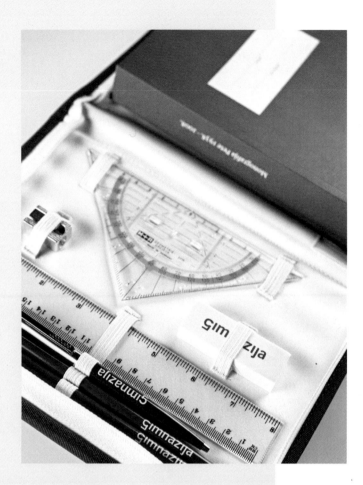

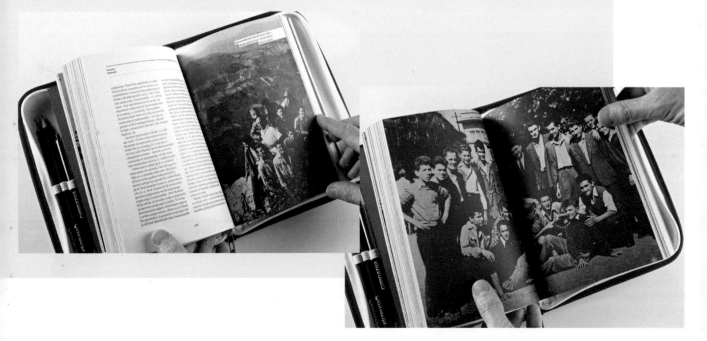

STUDIO EMMI **UNIVERSITY OF WESTMINSTER, UK**

Title
Degree Show Catalogue

Specifications
Size:
A5, 36 pages plus 8-page cover
Colour & Print:
cover: CMYK
inner pages: 1-colour (black)
Folding:
covers are folded in, creating
an 8-page cover
Binding:
saddle stitch

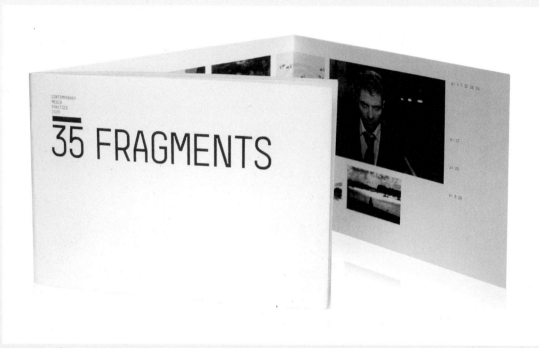

:030:030 **BERMER&CO.** CAJA NAVARRA, SPAIN

Title
Seminar at yhe Wharton School,
University of Pennsylvania

Specifications
Size:
90mm x 215mm, folded
540mm x 430mm, flat
Colour & Print:
CMYK
Paper:
Torraspapel, sepia, 80gsm
Folding:
6-page accordion

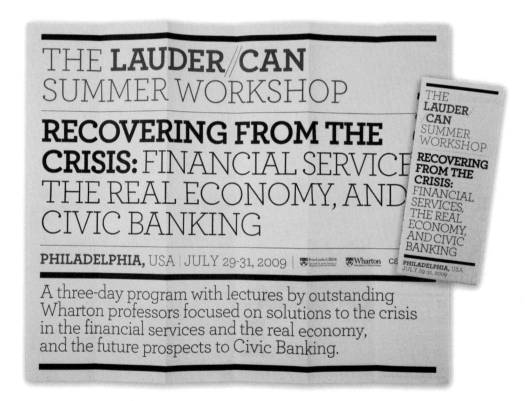

Folding:

6-PAGE ACCORDION

CONNIE HWANG DESIGN **UNIVERSITY GALLERIES, USA**

Title
Ten Plus Ten: Revisiting Patterns
and Decoration Exhibition catalogue

Specifications
Size:
A6, 16 pages plus cover wrap
Colour & Print:
catalogue: CMYK
wrap: 1-colour (Pantone metallic)
Folding:
accordion fold
Finishing:
deboss and diecut

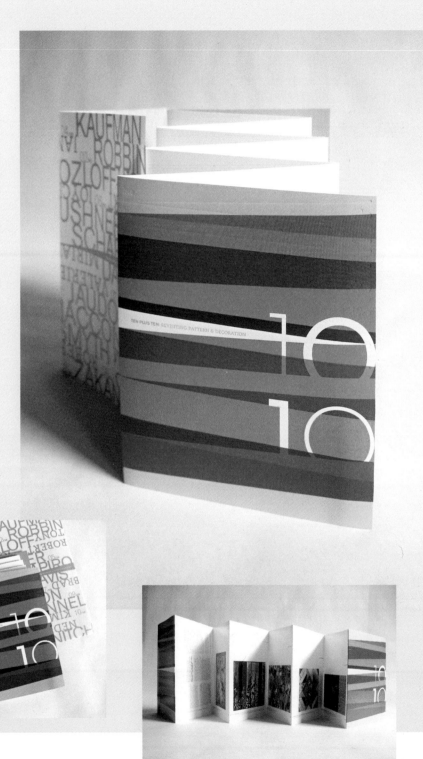

Title
Summer Diplomas 08

Specifications
Size:
A1 poster, folded to A3
A7 book, 140 pages
A6 postcards
Colour & Print:
2-colour, offset
black and gold silkscreen
Finishing:
hand drawings and writings

The poster was printed with an
empty bubble, which worked as
a base for freely hand-drawn
sketches. An announcement
was then printed on top of the
two layers.

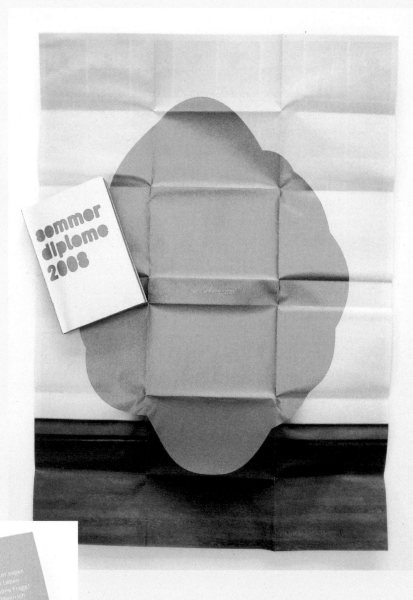

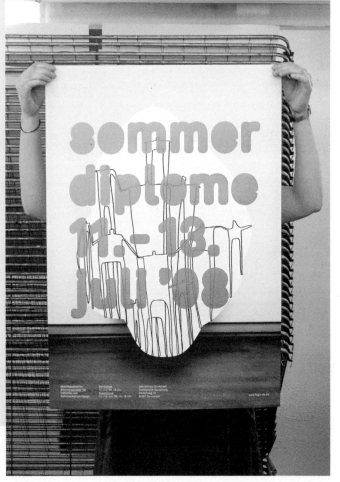

HOCHSCHULE DARMSTADT & PRACTISE FACULTY OF DESIGN, GERMANY

Title
Dear Lulu

Specifications
Size:
150mm x 210mm, 96 pages
Colour & Print:
CMYK, digital print on demand

The book is a self-produced calibration document for testing colour, pattern, format, texture and typography when printing with print on demand, on this occasion using lulu.com.

12–13 June 2008

Dear Lulu,

Please try and print these line, colour, pattern, format, texture and typography tests for us.

Alex, Alice, André, Andreas, Anja, Christoph, Frank, James, Juliane, Michael, Patrick, Rima & Tim

Hochschule Darmstadt, FB Gestaltung
Practise, London

Colour Portraits ROYGBIV / White

Adobe RGB (1998)

sRGB IEC61966-2.1

CMYK (Euroscale Coated v2)

Greyscale

Halftone Screen 40lpi / 45° / Round

Hypnosis Test

Division by one degree

Division by five degrees

Title

Goldsmiths 2009/10 Undergraduate Prospectus

Specifications

Size:

250mm x 200mm, 144 pages

Colour & Print:

CMYK

Paper:

Challenger Offset, made from ECF wood pulps acquired from sustainable forest reserves

Binding:

perfect bind

Finishing:

the cover features blind-embossed panels, adding to the tactile quality while avoiding non-recyclable materials such as foil blocking or spot laminates

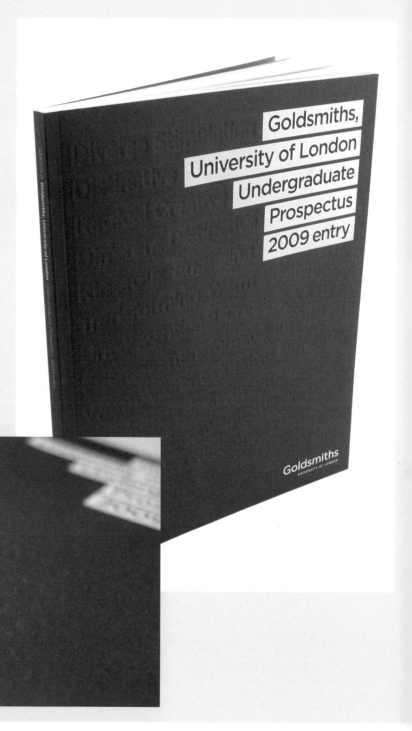

Contents

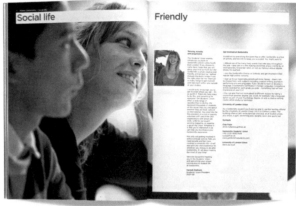

Social life Friendly

3 past residents of New Cross
Poet Robert Browning
Inventor Barnes Wallis
Actor Gary Oldman

8 Goldsmiths graduates
Julian Clary
Kanya King
Linton Kwesi Johnson
Lucian Freud
Sarah Lucas
Brian Molko
Julian Opie
Mary Quant

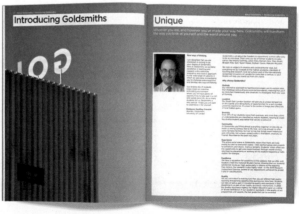

Introducing Goldsmiths Unique

Whoever you are, and however you've made your way here, Goldsmiths will transform the way you look at yourself and the world around you

Title
Zeit für die Bombe

Specifications
Size:
195mm x 260mm, 200 pages
Colour & Print:
1-colour (black), digital
Paper:
Medley Pure, Zanders
Binding:
swiss binding with a hard cover
Finishing:
laser cut holes

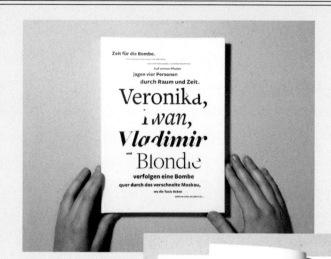

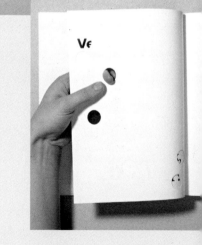

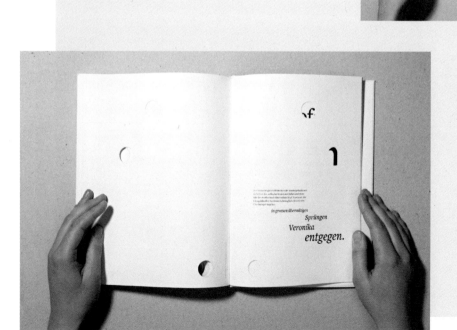

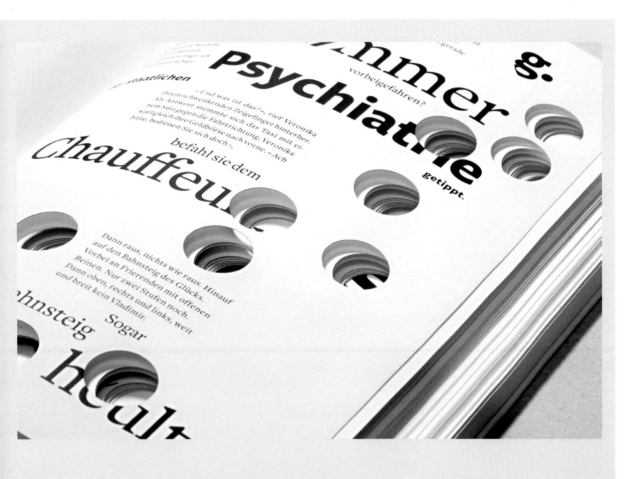

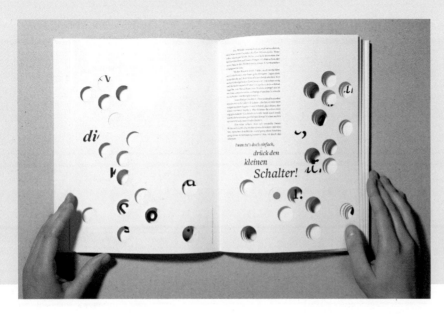

VISUAL THINK UNIVERSITY OF UTAH, USA

Title
What Is This?, University of Utah

Specifications
Size:
178mm x 203mm, folded
690mm x 990mm, flat
20 pages, 5 signatures, untrimmed

Colour:
front: 2-colour (fluorescent pink and black)
back: 2-colour (fluorescent orange and black)

Paper:
Fortune Matte Text, 70gsm, FSC, SFI and PEFC certified paper, which contains 10% post-consumer recycled fibre

Finishing:
user is required to trim the three edges along the dotted lines, making the document into a book

Designed in partnership with the University of Utah graphic design students. This poster teaches the reader about selecting and using typefaces and demonstrates how a book takes shape during the print production process.

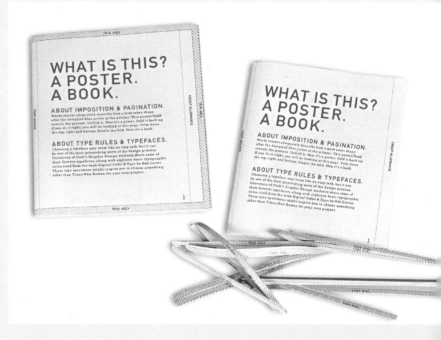

Finishing:

TRIMMING

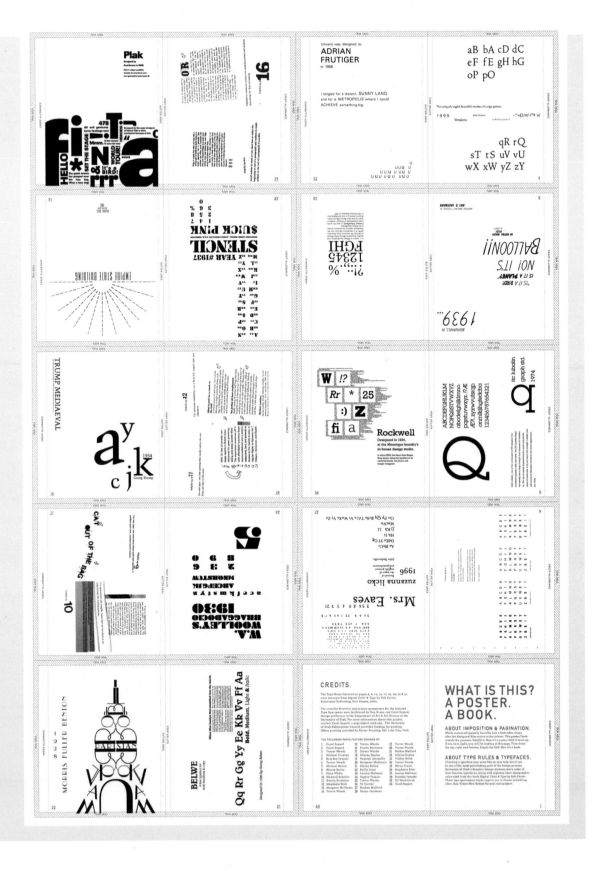

--

LUCIENNE ROBERTS + **UNIVERSITIES UK, UK**

Title
Annual Review 2008/09

Specifications
<u>Size</u>:
210mm x 250mm plus throw out
from p2 measuring 185mm wide
<u>Colour & Print</u>:
CMYK
<u>Paper</u>:
cover: Revive Uncoated, 300gsm
inner pages: Revive Uncoated,
140gsm
<u>Finishing</u>:
index tabbed, seal throughout

Cover illustration: Clara Terne

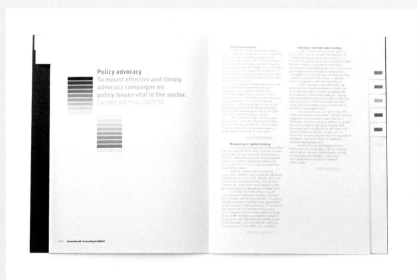

Only the TOC-style text on the right side is clearly legible.

Our vision and mission

Universities UK (UUK) is the major representative body and membership organisation for the higher education sector. Our 133 members are the executive heads of UK universities. Within it are the England and Northern Ireland Council, Universities Scotland and Higher Education Wales (HEW).

Our vision is of an autonomous university sector in the United Kingdom that, through excellence in teaching, research and knowledge exploitation, raises aspirations, has an international reputation for innovation, and contributes to the wider economy and society.

Our mission is to be the essential voice and the best support for a vibrant, successful and diverse university sector, to influence and create policy for higher education, and to provide an environment where the interests of our sector can flourish.

fold out
The year at a glance

Foresight
06/07

Policy advocacy
08/09

Promoting the sector
10/11

Communication
12/13

Collaboration
14/15

Fit for purpose
16/17

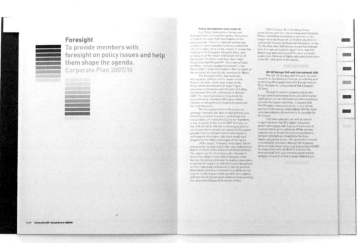

Foresight
To provide members with foresight on policy issues and help them shape the agenda.
Corporate Plan 2007/10

Title
Genome-wide Approaches Towards
Identification of Susceptibility
Genes in Complex Diseases

Specifications
Size:
170mm x 240mm, 176 pages
Colour:
2-colour (Pantone 805C and
Pantone 8260C)
Paper:
G-Print, 135gsm, FSC certified
Folding:
the poster forms a dust-jacket
Binding:
sewn binding without hard cover

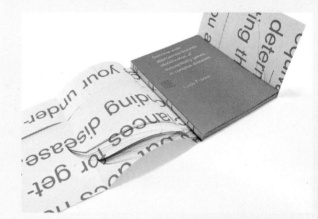

Binding:

SEWN SECTION

approach
identification ge
susceptibility ge
in complex diseases

Genoomwijde
strategieën tot de
identificatie van
ziekte veroorza-
kende genen in
complexe ziekten

Lude Franke

a-
oup
up

ou acknowledge your un
anding of genetic risk as a sta
stical measure that has implica
ons derived from a large group
of people with characteristics
equivalent to yours but does n
determine your chances for
the corresponding di

Title
The European Higher Education
Area: Celebrating a Decade of
UK Engagement

Specifications
Size:
210mm x 250mm
32 pages plus 4-page cover
Colour & Print:
CMYK and 1-colour (fluorescent)
Paper:
cover: Cocoon Offset, 350gsm
inner pages: Cocoon Preprint,
140gsm
Binding:
saddle stitch using red wires
Finishing:
UV varnish on cover

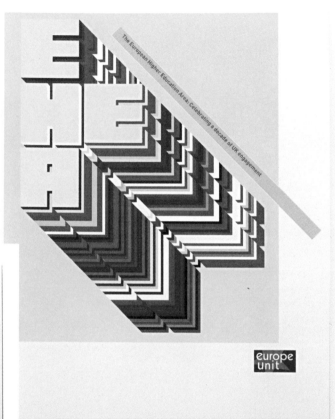

Title
Sommese Endowment for Graphic
Design Announcement

Specifications
Size:
160mm x 215mm, folded
160mm x 365mm, flat
Colour & Print:
CMYK
Paper:
Finch Fine Cover, 100gsm
Folding:
6-page accordion with extended panel

Folding:

6-PAGE ACCORDION WITH EXTENDED PANEL

TODY EDWARDS, LUKE ELLIOTT, JOE STEPHENSON NOTTINGHAM TRENT UNIVERSITY, UK

Title
Graphic Design Degree Show Invite

Specifications
Size:
130mm x 84mm
Colour & Print:
1-colour (black), silkscreen
Paper:
insert: GF Smith Colorplan Tabriz
Blue, 700gsm
sleeve: GF Smith Colorplan Ebony,
120gsm
Finishing:
laser cut logo with laser
engraved folds

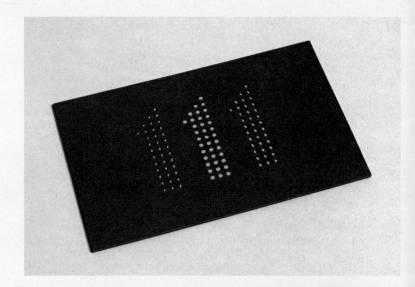

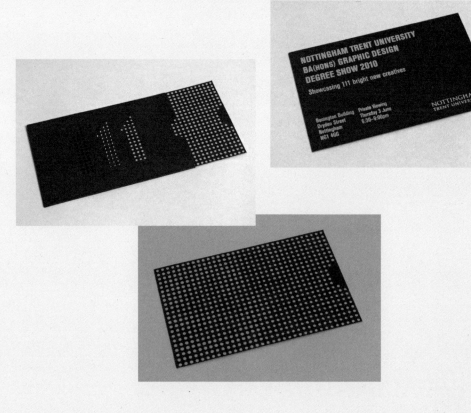

Print:

SILKSCREEN

Title
5 Jahre Labor Visuell

Specifications
Size:
flyer: A2 folded to A5, 16 pages
brochure: A5, 48 pages
Colour & Print:
2-colour (black and HKS-spot
colour)
Paper:
BVS matt coating by Scheufelen,
FSC certified
flyer: 80gsm, brochure: 150gsm
Folding:
the folded flyer also serves as
a poster and as a dust jacket for
the brochure

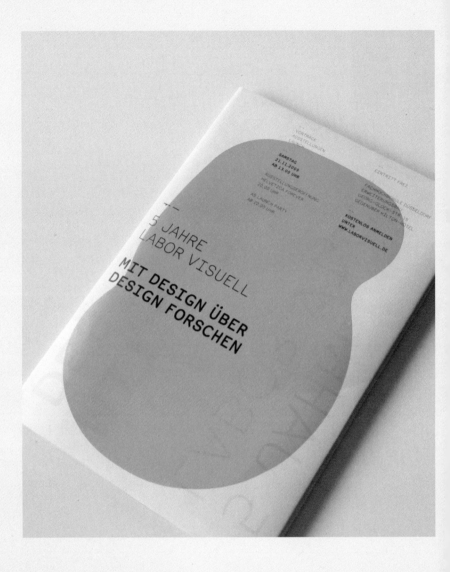

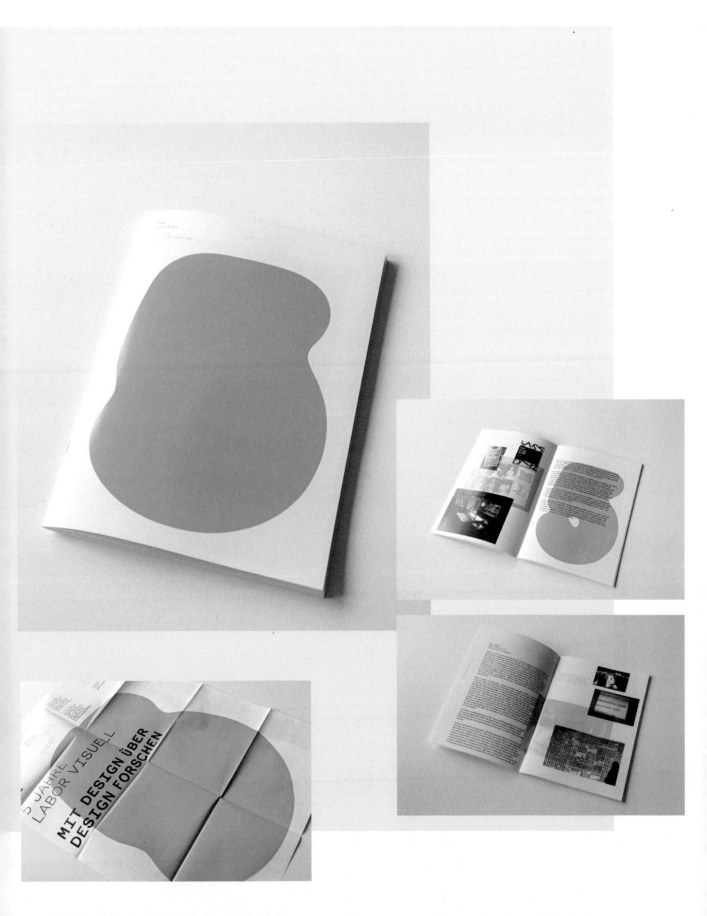

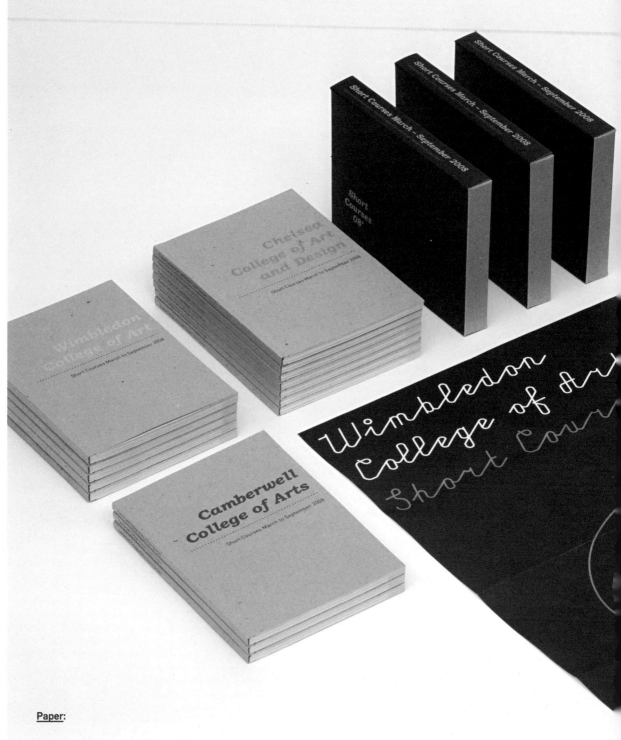

<u>Paper</u>:

RECYCLED

Title
CCW Short Course Prospectuses

Specifications
Size:
165mm x 120mm
16 pages and 64 pages
Colour & Print:
16 pages: CMYK
64 pages: 2-colour
cover: 1-colour
mailer: 1-colour
Paper:
cover: Testliner 500micron
16 pages: Revive 50-50 Gloss, 150gsm
64 pages: Cyclus Offset, 115gsm
all recycled stock
Binding:
perfect bind
Finishing:
foil blocked title on the cover; a
custom designed testliner mailer
that houses all three prospectuses
with a single spot colour sticker,
measuring 60mm in diameter

CCW embodies the three college
alliance of Camberwell College
of Arts, Chelsea College of Art
and Design and Wimbledon
College of Art.

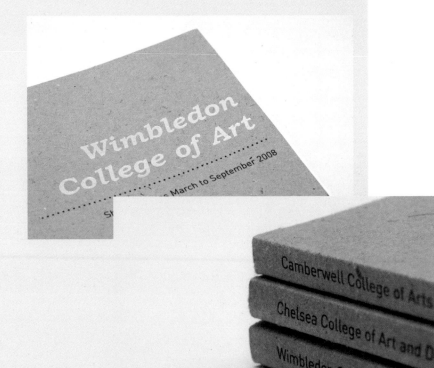

Title
Goldsmiths Masters of Fine
Art Catalogue

Specifications
Size:
287mm x 225mm
16 short pages
96 full-size pages
Colour & Print:
short pages: 1-colour (black)
full-size pages: CMYK
Paper:
cover: Corona Pearl Grey, 120gsm
paper over 2.3mm boards
short pages: Corona Pearl Grey
full-size pages: Chromomatt, 130gsm
Binding:
casebinding with quarter bind in
brillianta dark grey cloth.
Finishing:
debossed cover title, foil blocked
spine title in red

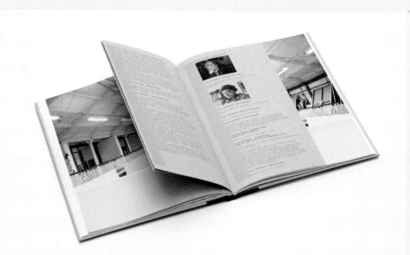

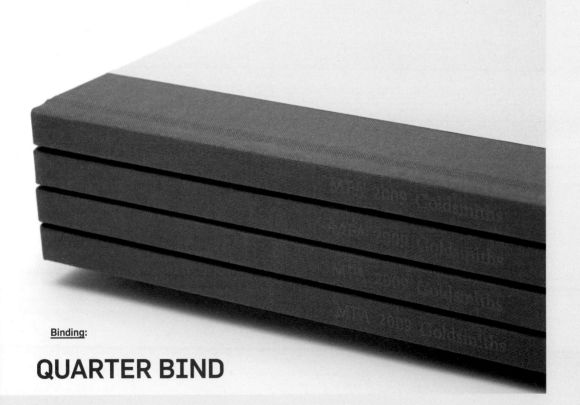

Binding:

QUARTER BIND

Title

Representing Architecture
New Discussions: Ideologies,
Techniques, Curation

Specifications

Size:
148mm x 200mm

Colour & Print:
cover: 1-colour (fluorescent)
pages 1-32: 1-colour
pages 33-40: CMYK
pages 41-100: 1-colour

Paper:
cover: Robert Horne Natural, 300gsm
inner pages: Robert Horne
Natural, 120gsm

Finishing:
folded corners for each chapter
opener

Each academic paper uses a
different font designed by Adrian
Frutiger, in recognition of his 80th
birthday in 2008.

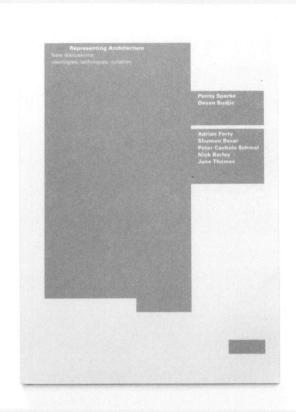

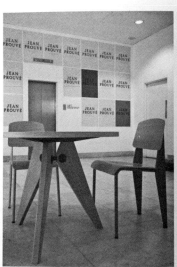

The Design Museum café, featuring
Jean Prouvé exhibition posters
by Graphic Thought Facility, 2008.
Furniture by Jean Prouvé kindly
loaned by Vitra.

Adrian Forty

42/43

PATRIC SANDRI HSLU LUCERNE, SWITZERLAND

Title
Degree Show Poster

Specifications
<u>Size</u>:
895mm x 1280mm
<u>Colour & Print</u>:
2-colours (black and gold),
silkscreen
<u>Paper</u>:
biotop

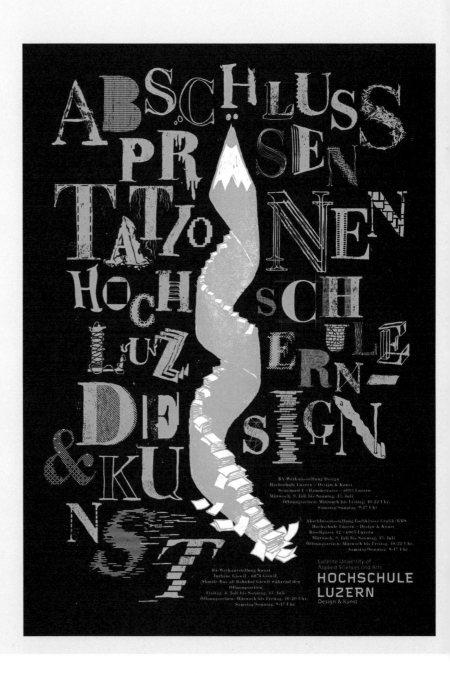

Chapter Two:

ARTS

Document designs for artists and exhibitions are often the most creative briefs around. Successful case studies contain clever design solutions, reflecting the artist's work while maintaining the focus on the artist or event. A good example of this is the Longplayer Live programme leaflet by Fraser Maggeridge Studio. p. 80 The format for the 20-page, two-metre long leaflet was chosen to reflect the magnitude of the Longplayer concept: a one thousand-year long musical composition.

Limited budget can also become part of an innovative solution, like THIS IS Studio's work for the 176 Gallery. p. 98 The brief was to design a flyer for a summer exhibition 'A Tradition I Do Not Mean to Break'. The designers realised that although they had a small print budget, they could actually produce something bigger and more memorable by using postcards that were already printed for the exhibition as the images, escaping the need to print 4-colour and alleviating a bigger budget for stock and finishing processes such as die cutting.

Working with Galerie Hippolyte, Chris Bolton faced a different kind of problem – at the time of design, there were no images available. The solution was to explain the images in words; in their own manner, they reflect the artwork, leaving viewers to make their own opinions. This also allowed the whole document to be printed in one colour only. p. 74

Title
Update #1 Caspar Berger

Specifications
Size:
20 pages with progressive page
widths
Colour & Print:
CMYK
Paper:
Arctic Volume White Plano, 170gsm
Binding:
three-hole sewn
Finishing:
brochure inserted into a custom-
made sleeve

Binding:

THREE-HOLE SEWN

Title
Roger Hiorns

Specifications
<u>Size</u>:
160 pages
<u>Colour & Print</u>:
cover: 1-colour (black)
inner pages: 4-colour (CMYK)/
1-colour (black)
<u>Paper</u>:
hardback, paper covered boards
<u>Binding</u>:
hardback

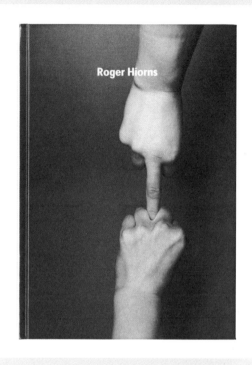

<u>Printing</u>:

4/1

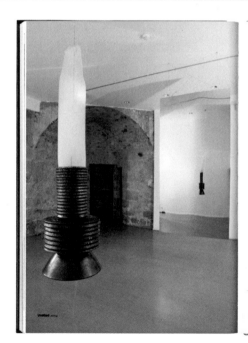

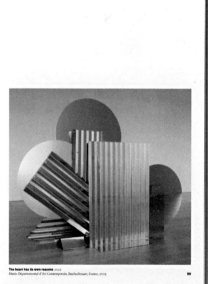

All images courtesy Cervi-Mora, London unless otherwise stated.

p. 17
The coming afflictions suffered for the dirt of love 2005
Metal, paint, copper sulphate
225 × 298 × 6.5cm
Private Collection

p. 18
Im Winter 2002
Galvanised steel, paint, thistles, copper sulphate
162 × 80 × 37cm
Collection of Ninah and Michael Lynne, New York

p. 19
Joy 2003
Steel, perfume (_Joy_, Jean Patou)
148 × 26 × 9cm
Courtesy Marc Foxx, Los Angeles

pp. 28–29
The heart has its own reasons 2002
Stainless steel, nylon
162 × 214 × 60.5cm
Private Collection

p. 30
Creed 2003
Steel, perfume (_Fleurs de Bulgarie_, Creed)
134 × 26 × 9.5cm

p. 20
L'heure bleue 2003
Steel, perfume (_L'Heure Bleue_, Guerlain)
145.5 × 26 × 9cm
Private Collection
Courtesy Galerie Nathalie Obadia, Paris

p. 21
The pleasure received in pain 2005
Airduster, carbats
25.5 × 20 × 8cm
Collection of Konstantinos Papageorgiou, Athens

p. 22
Discipline 2002
Steel, thistles, copper sulphate, velcro
314 × 66 × 51cm
British Council, London

p. 31
Vauxhall 2004
Steel, perfume (_First_, Van Cleef & Arpels)
134 × 26 × 9.5cm
Private Collection

p. 32
Untitled (IBM 15 x 10) 2000
Ceramic, plastic, compressor, foam
30 × 25cm
Private Collection

p. 33
Temporary construction to hidden obligations 2001
Steel, enamel, nylon
162 × 214 × 60.5cm
Private Collection

p. 23
Come with me to the forest it's dark now and everyone will be gone we'll walk gently through the gates of joy and see the birth of the rare bird 2005
Oak
168 × 192 × 6 cm
Collection of Konstantinos Papageorgiou, Athens

p. 26
Weakness 2005
Metal, paint, copper sulphate
230 × 280 × 6 cm
Collection of Alice Kosmin, New York

p. 27
Working out for It's They Me Or The Red Hawthorne Tree 2005
Pencil on paper, framed
55 × 63.5 × 3cm

p. 34
Weakness 2004
Bronze
23 × 18.5 × 6.5cm
Edition of nine and two artist's proofs
Various private collections

p. 35
Routine 2005
Cardboard, resin
70 × 48 × 13cm

p. 37
L'instant 2004
Steel, perfume (_L'Instant_, Guerlain)
147.5 × 26 × 9cm
Collection of Oliver Ferreira, New York

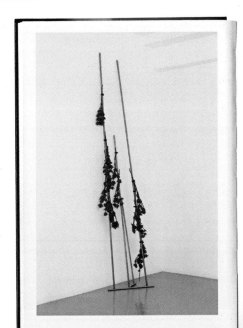

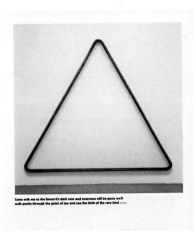

Come with me to the forest it's dark now and everyone will be gone we'll walk gently through the gates of joy and see the birth of the rare bird 2005

Discipline 2002

Title
Invasionswetterlage

Specifications
Size:
148mm x 210mm
Colour & Print:
cover: 1-colour (white), silkscreen
inner pages: 1-colour (black)
Paper:
Plano Color (black, yellow, red),
80gsm and 160gsm
Binding:
saddle stitch

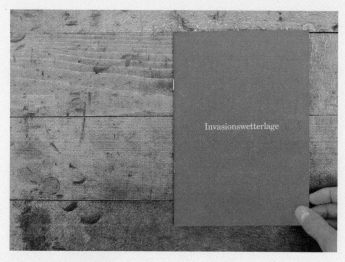

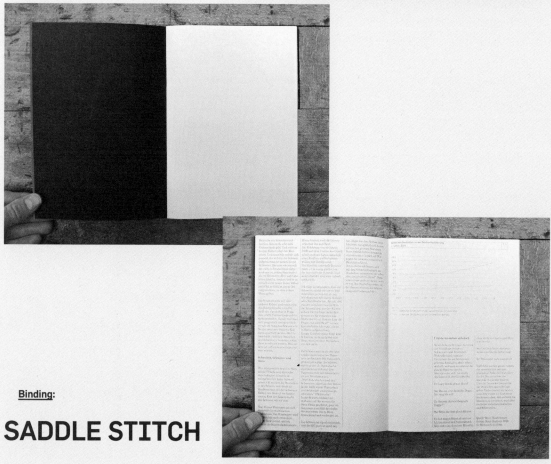

Binding:

SADDLE STITCH

CHRIS BOLTON **GALERIE HIPPOLYTE, FINLAND**

Title
An Exhibition Curated by
a Very Important Curator

Specifications
Size:
A6, 16 pages
Colour:
2-colour
Paper:
Munken Lynx, FSC certified
Binding:
saddle stitch

At the time of design, there were no
digital images available. The solution
was to explain the images in words.
In their own manner, the words
reflect the artwork, leaving viewers
to make their own opinions.

A DRUNKEN MAN IS SWAYING
IN FRONT OF THE MIRROR
YOU CAN HEAR THE SOUND OF A
MOTOR IN THE BACKGROUND

kivat
ivihkaa
ikkeiden

agination
llows
ace of

STALLAATIO

TITLE:
FROM THE SERIES
"BREATHE" 2008

MEDIUM:
LIGHT BOX INSTALLATION

05

CHRIS BOLTON **HELSINKI CITY ART MUSEUM, FINLAND**

Title
Yours Truly

Specifications
Size:
250mm x 250mm, 36 pages
Colour & Print:
CMYK plus 1-colour (gold) on cover
Paper:
Galerie Silk, FSC certified
Binding:
section sewn
Finishing:
die-cut cover

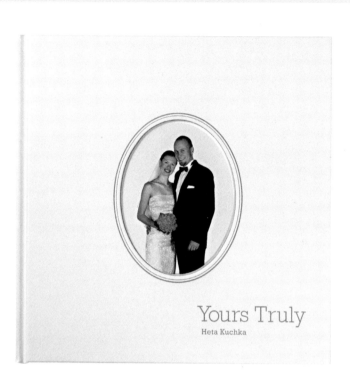

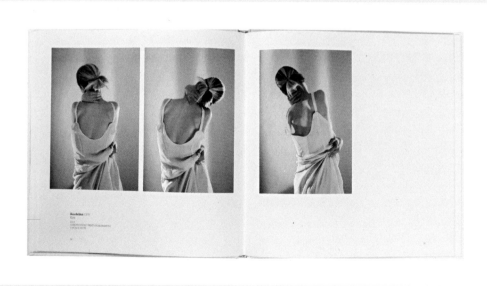

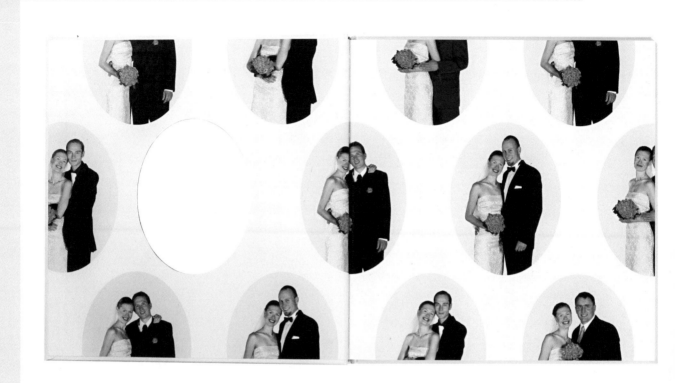

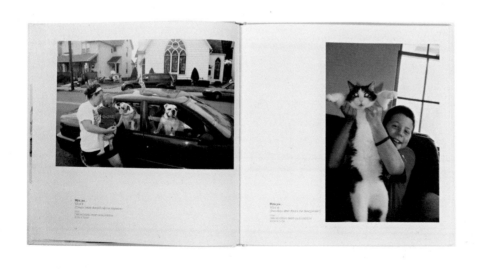

Title
The Book of Genesis

Specifications
Size:
210mm x 270mm, 400 pages
Colour & Print:
CMYK
Paper:
cover: artificial leather
inner pages: Munken Pure, 150gsm
Finishing:
die-cut circle on 112 pages
holds a CD; two silk ribbon
bookmarks are bound into the
book at the top of the spine

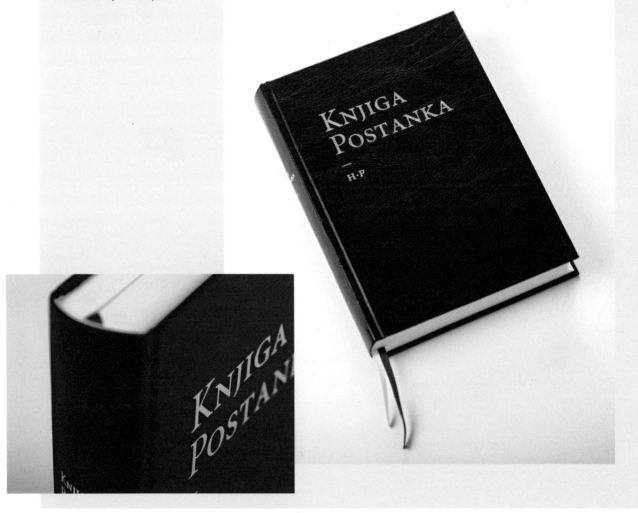

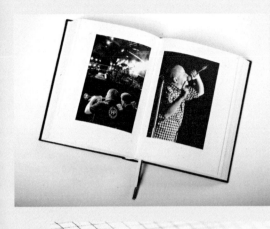
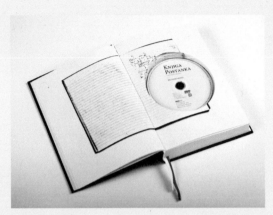

FRASER MUGGERIDGE STUDIO **THE LONGPLAYER TRUST, UK**

Title
Jem Finer, Longplayer
Live Programme

Specifications
Size:
2m long, 20 pages
Colour:
1-colour (black)
Paper:
brown packaging paper
Folding:
concertina fold, joined with
blue binding tape as the format
was too long to make from one
single sheet

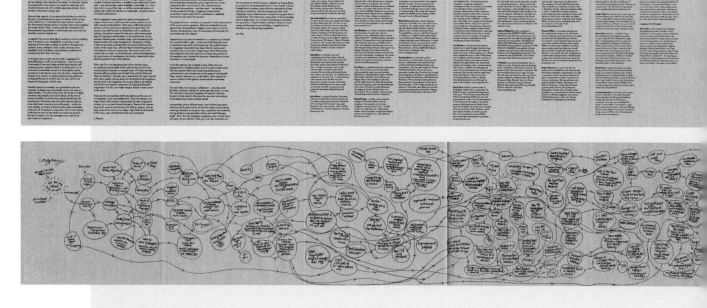

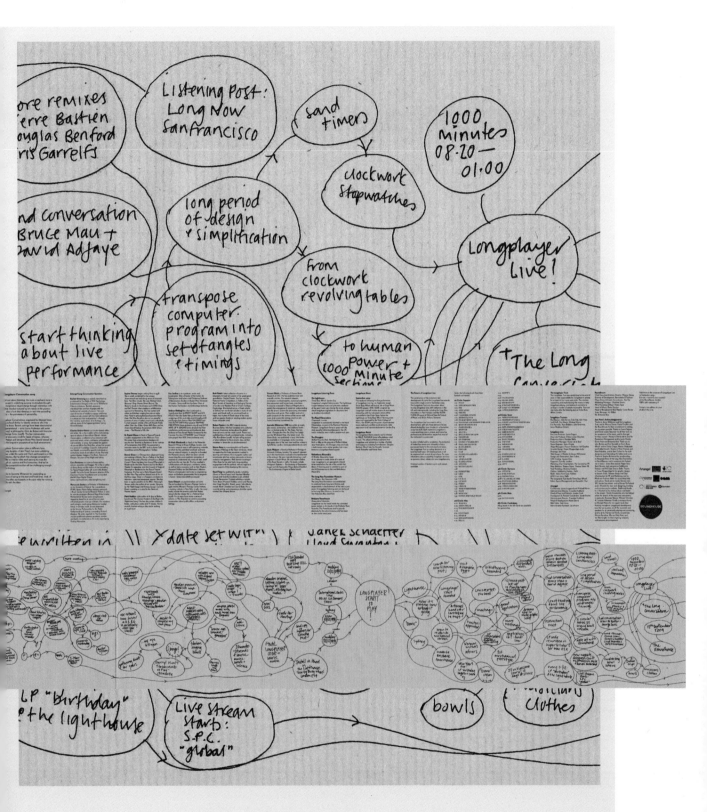

CHRIS BOLTON GALERIE HEINO, FINLAND

Title
In Memory of...

Specifications
Size:
175mm x 230mm, 32 pages
Colour & Print:
cover: 1-colour
inner pages: CMYK
Paper:
cover: recycled board
inner pages: Galerie Silk
Binding:
section sewn with black-cloth spine,
affixed front and back covers

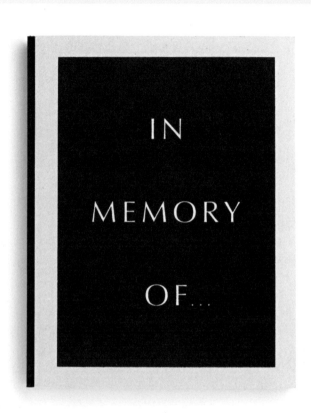

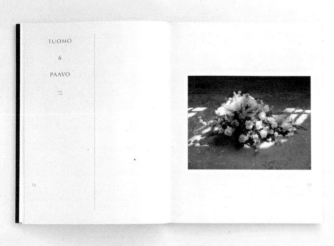

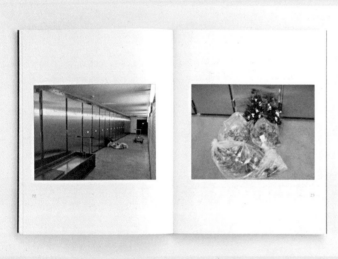

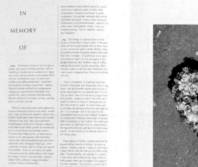

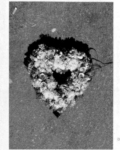

.004:005

Title
Drawn in the Clouds

Specifications
Size:
195mm x 265mm, 64 pages
Colour & Print:
section 1: 2-colour
section 2: CMYK
Paper:
Munken Lynx (uncoated stock used
for Texts section) and Galerie Art
Silk (contrasting coated stock used
for Image section), FSC certified
Binding:
casebinding
Finishing:
silver foil blocking on cover

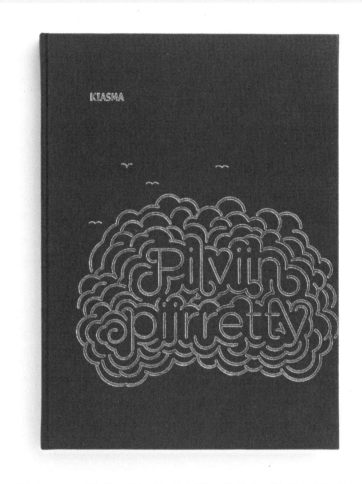

Finishing:

FOIL BLOCKING

Title
First Aid for Design

Specifications
Size:
125mm x 175mm, 32 pages
Colour:
1-colour (black)
Paper:
four types of coloured paper stock,
200gsm
Binding:
perfect bind
Finishing:
four black ribbon bookmarks bound
into the book at the top of the spine

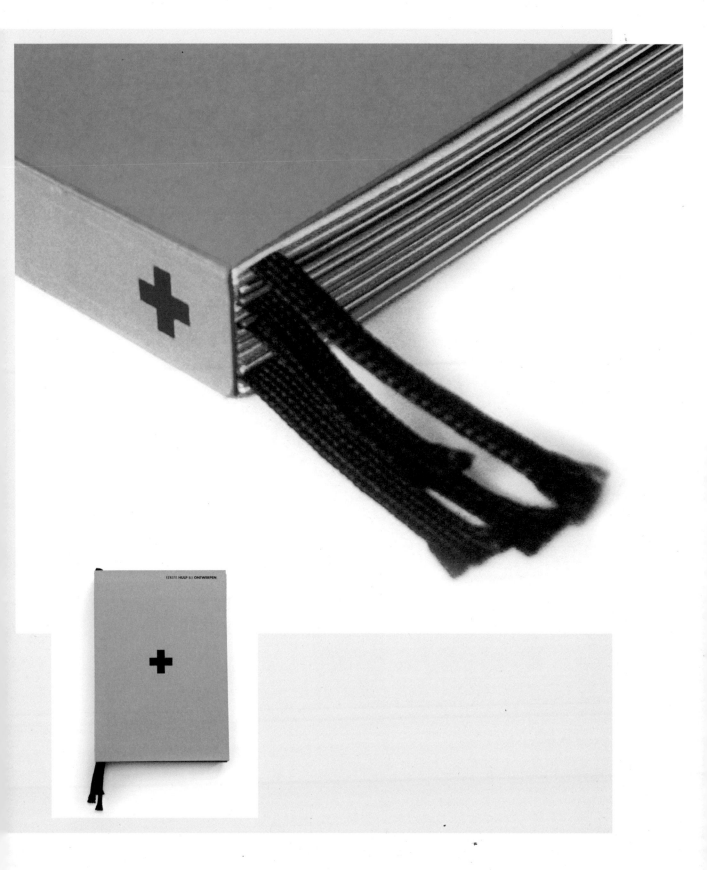

DESIGN AGENCY TANGO **THE ASSOCIATION OF FINNISH SCULPTORS, FINLAND**

Title
100 Years, The Association
of Finnish Sculptors

Specifications
Size:
poster: 350mm x 700mm
brochure, folded, two sided:
297mm x 420mm
envelopes: A4 and A5
Colour:
2-colour (Pantone 872 and black)
Paper:
Munken Polar
Folding:
brochure: 8-page accordion
Finishing:
blind embossing

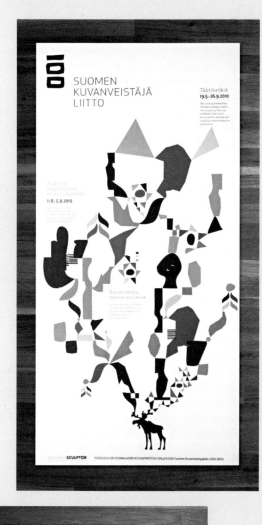

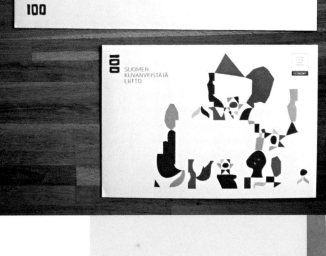

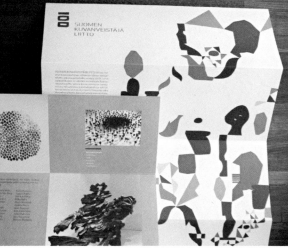

:090:091

HUDSON-POWELL **176/ZABLUDOWICZ COLLECTION, UK**

Title
Matt Stokes / The Gainsborough
Packet, &c.

Specifications
Size:
148mm x210mm, 76 pages plus
4-page cover
Colour & Print:
CMYK plus 1-colour
Paper:
Starline Kraftback, Munken Print
White, Munken Print Cream,
Maxigloss, Clairefontanie Pink
Binding:
section sewn
Finishing:
embossed cover

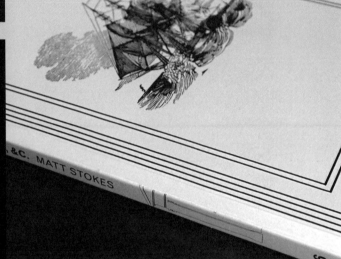

Title
Page Tsou

Specifications
Size:
closed: 115mm x 200mm
open: 329mm x 483mm
Colour & Print:
cover: 1-colour (black), laser
inner pages: 1-colour (black),
risograph
Paper:
cover: Folders Buff Paper
inner pages: Paperback Corona
Offset, 130gsm
Binding:
swiss binding

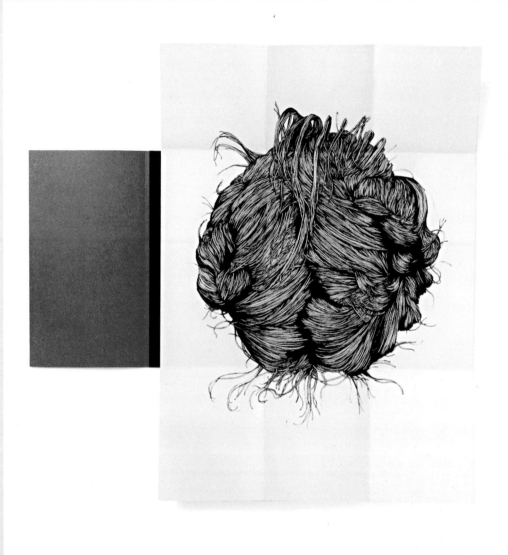

PAGE TSOU QUENTIN

PAGE TSOU ROGER

PAGE TSOU HANNAH B.

PAGE TSOU DAVID

PAGE TSOU HANNAH W.

PAGE TSOU NAHYUN

PAGE TSOU XAVIER

Title
Kelly Large, Our Name Is Legion

Specifications

Size:
16 pages plus 4-page cover

Colour & Print:
cover: 1-colour (fluorescent)
inner pages: 12 pages printed
1-colour (black) and wrapped
around a 4-page (CMYK)
middle section

Binding:
saddle-stitch

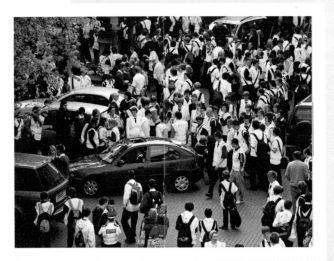

344 DESIGN, LLC **L.A. LOUVER, USA**

Title

Rogue Wave Catalogue

Specifications

Size:
12" x 7" with a 12° angle cut on the fore edge, 80 pages

Colour & Print:
CMYK
center section: CMYK plus 1-colour (PMS grey)

Paper:
FSC certified

Binding:
perfect bind

Finishing:
spot gloss varnish on both covers

The book works from both sides to give both shows equal coverage. The introduction is at the center and the pages flow out towards the covers in alphabetical order.

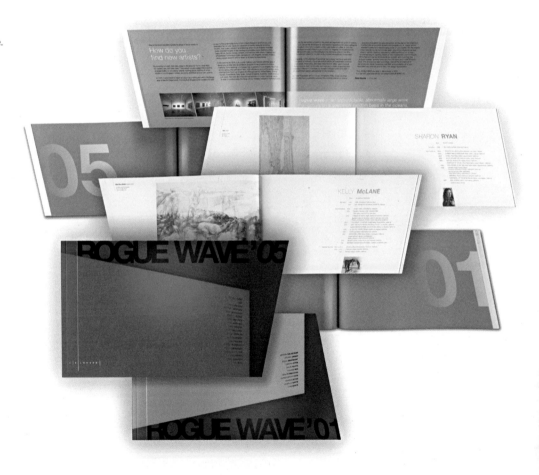

DAN ALEXANDER & CO **ERETZ ISRAEL MUSEUM, ISRAEL**

Title
Itay Noy, A Second Second

Specifications
Size:
A4
Colour & Print:
inner pages: CMYK plus metallic
spot colour
Paper:
cover: leather-like paper stock
Binding:
section sewn, hard back
Finishing:
embossed cover

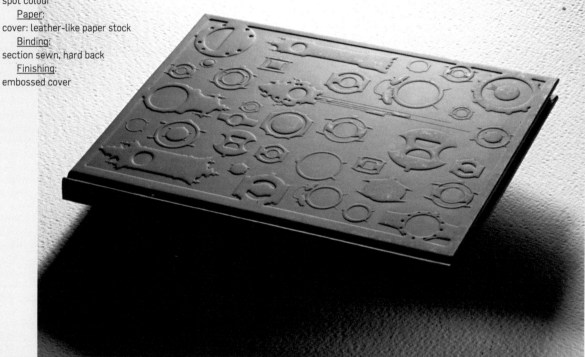

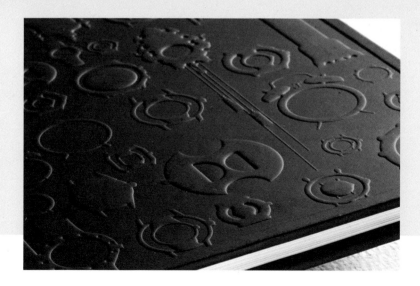

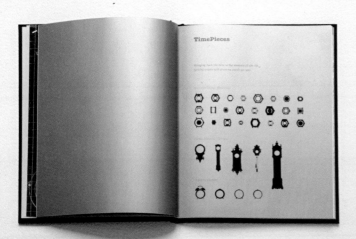

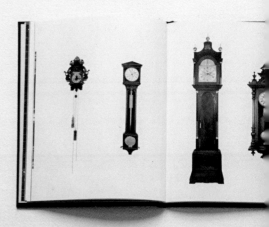

THIS IS STUDIO **176 GALLERY, UK**

Title
A Tradition I Do Not Mean to Break

Specifications
Size:
210mm x 140mm
Colour & Print:
1-colour (Pantone)
Paper:
Cairn Natural Cream, 320gsm,
100% recycled
Finishing:
10-page concertina fold with
die cuts

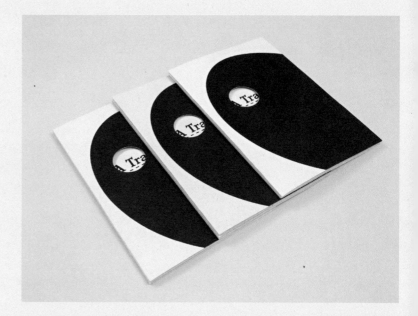

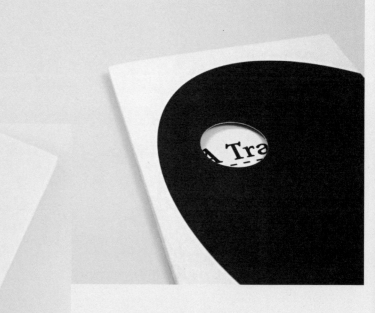

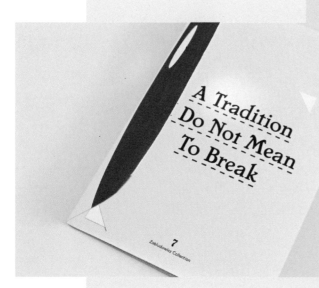

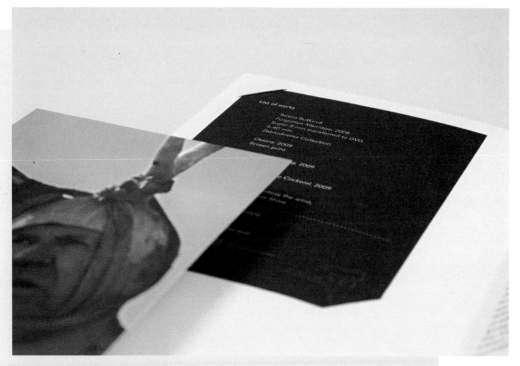

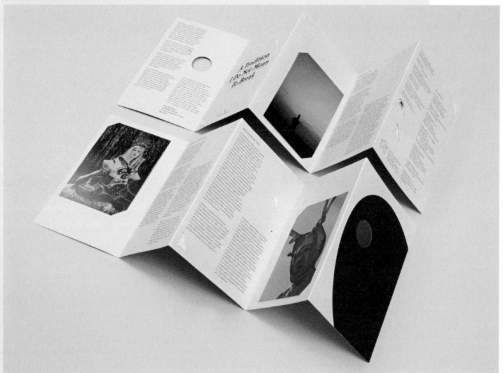

CONCERTINA

Title
The Violence

Specifications
Size:
230mm x 335mm, 200 pages
Colour & Print:
2-colour (Pantone black overprint
and Pantone 7506), silkscreen
Paper:
front and back sections: Scandia
2000, 150gsm
The violent Altamont section from
California 1969: Bible paper, 60gsm
Jonas's artwork section: Scandia
2000, 130gsm
Binding:
open-spine and thread-sewn binding
Finishing:
spot varnish; rounded corners; 700
copies signed by the artist

Binding:

OPEN SPINE

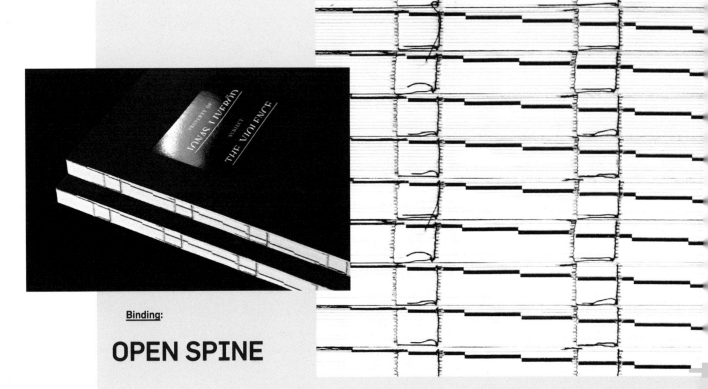

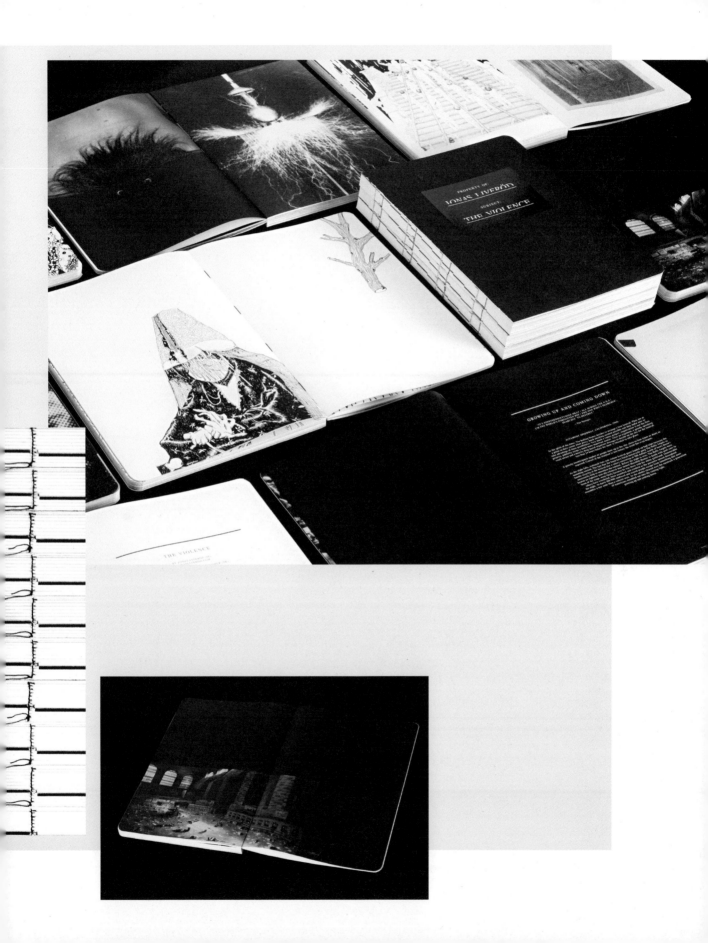

VT.IF890 ONTWERPERS ZUIDERZEE MUSEUM, NETHERLANDS

Title
Monument / Clare Twomey

Specifications
Size:
160mm x 240mm, 40 pages
Colour & Print:
CMYK
Paper:
Biotop, 150gsm
Binding:
thread-sewn section
Finishing:
embossed cover; each inner
page perforated

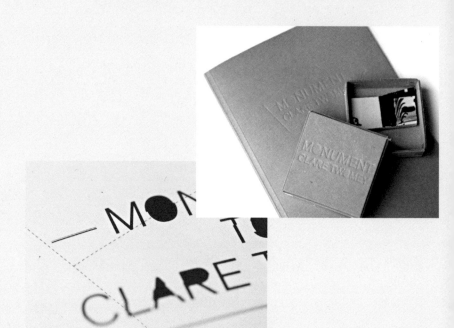

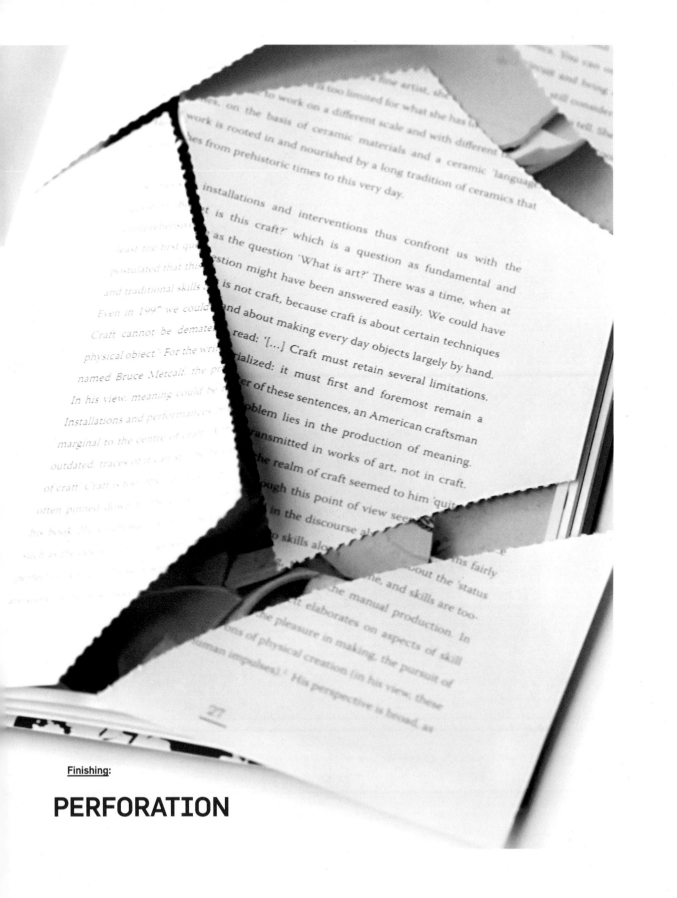

Finishing:

PERFORATION

Title
Order

Specifications
Size:
230mm x 300mm, 70 pages
Print:
digital
Paper:
cover: HP Photo Paper, 300gsm
inner pages: Digital Uncoated,
120gsm
Binding:
french fold

With bespoke typography.

Format:

FRENCH FOLD

ORDER

STUDIO BAER **HOST GALLERY, UK**

Title
Maurice Broomfield Monograph

Specifications
Size:
200mm x 254mm, 128 pages
Colour & Print:
CMYK
Paper:
book: pristine white heavy-weight
paper with black uncoated
endpapers
box: light-grey uncoated paper stock
Binding:
thread-sewn section
Finishing:
a limited edition of 100 signed and
numbered books are presented
in a custom-made portfolio case
with an accompanying signed silver
gelatin print

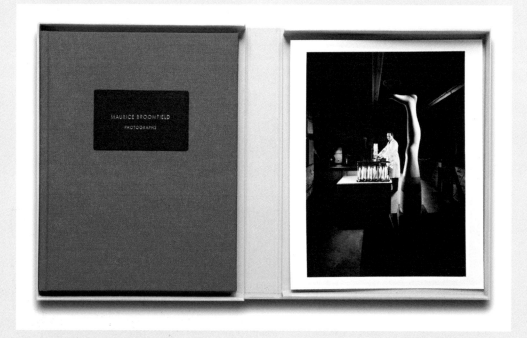

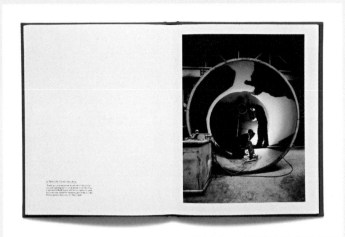

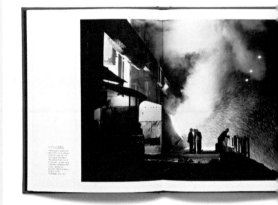

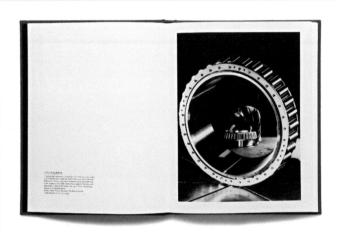

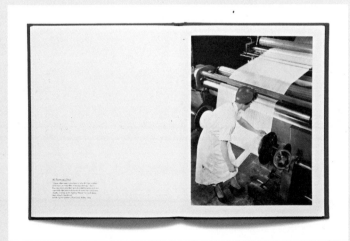

Design Client

SARAH BORIS THE INSTITUTE OF CONTEMPORARY ARTS, UK

===

Title
ICA Monthly Guide

Specifications
Size:
A5, an average of 32 pages
Colour & Print:
1-colour (black), litho
Paper:
Challenger, 70gsm, FSC certified
virgin fibre content, sourced from
well-managed and sustainable
forests
Binding:
saddle stitch

Font: Theinhardt by Optimo

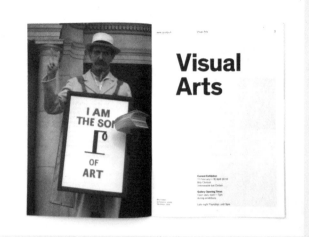

For the blind man in the dark room looking for the black cat that isn't there

3–23 December, 2–31 January

This acclaimed international group exhibition includes works by more than 20 modern and contemporary artists, including still lifes by Giorgio Morandi, a celebrated film by Fischli & Weiss, and a sculptural installation by Dave Hullfish Bailey.

The exhibition celebrates the speculative nature of knowledge, rejecting the common assumption that art is a code that needs cracking and presenting works that employ nonknowledge, unlearning and productive confusion as ways to understand the world.

Stretching 16 metres along one wall in the lower gallery is an installation by Mell Mulkcin, including drawings, flags, diagrams, rubbings, photographs and paints, deconstructing Mulkcin's highly subjective theory of everything. The lower gallery also has a selection of photographs by Bruno Munari, showing the artist fruitlessly looking for a black cat in an unconfirmable, cruel, and a large-scale installation by Trevor Mann and Fabio Pravat which will be continually re-arranged over the course of the exhibition.

The installation takes its title from a notion attributed to Charles Darwin, comparing mathematical

enquiry to the explorations of a blind man. The project also reads to The Blind Man, the journal co-handled by Marcel Duchamp & re-issue of which the artist Sarah Crowest is presented in the ICA's mezzanine. Other works here include a game by David Adilkin which encourages visitors to engage with the idea of the fourth dimension, and a large potato to Mariana Castillo Deball in the shape of a 48-sheet poster.

At the foot of the stairs leading to the Upper Galleries you meet Marcel Broodthaers, intervening for call blend title art of painting a recording from 1970, while inside the galleries artist duo Heerhartdini,

COSEY COMPLEX

&

Cosey Club

Saturday 27 March

1—6pm (Complex)
10pm—3am (Club)

COSEY COMPLEX is a special one-day event, conceived by writer Maria Fusco and commissioned by the ICA that has developed from conversations between Fusco and artist and musician Cosey Fanni Tutti. Cosey is known as a member of the art-music groups COUM Transmissions and Throbbing Gristle, and for her solo activities which include works based on appropriated pornographic images of herself. Today's event builds on the shared interests of Fusco and Fanni Tutti in language and sexual relations. The event starts with an afternoon session involving a range of artists, writers and other practitioners who have been asked to contribute works that examine and are inspired by 'Cosey as Methodology'. While the session involves some of the traditional formats of a conference, such as academic presentations and discussion panels, it also includes experimental responses, investigations and performances. Participants include Martin Bax, Geraldine Byrne, Marquis Cassidy, Cosey Fanni Tutti, Graham Duckenham, Graham Dufft, John Duncan, Anthony Elms, Robert Orlon, Chris Kraus, Pat Ryan, Diana Reid and Rob Stone. The day concludes with Cosey Club, a regular club night brought to the ICA under the rubric of 'Cosey as Methodology', which tonight features bands and DJs including Factory Floor, Carter Tutti, Throbbing Gristle...

Artists' Film Club

Haris Epaminonda

Monday 22 March
7pm

This month's Artists' Film Club presents the work of Haris Epaminonda. With disparate images, Epaminonda creates short films sequences and montages, playing with cuts, repetition and orientation. Her enigmatic works, which have an emotive and ostensible appearance, often feature found footage from the 60s and 70s—including scrap-opener and amateur holiday films.

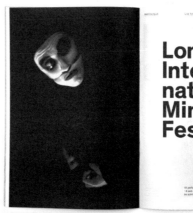

London International Mime Festival

All performances suitable for ages 14 and over. Latecomers may not be admitted.

Information
www.ica.org.uk/mimefestival
020 7930 3647

Music

Information
www.ica.org.uk/music
020 7930 3647

Title
The Embassy

Specifications
Size:
205mm x 255mm, 96 pages
Colour & Print:
CMYKoffset
Paper:
cover: Fedrigoni Constelation Snow,
250gsm
inner pages: Fedrigoni Splendorgel,
140gsm, Fedrigoni Vellum, 100gsm
Binding:
perfect bind

The Embassy was an exhibition that
took place at the former Embassy
of Sierra Leone in London where
the building was used as diplomatic
facilities of a fictional, problematic
country. Use of understated
typography for the catalogue gives
it a bureaucratic feel, a deliberate
reference to the official theme of
the exhibition. This is also reflected
in the cover, featuring the United
Nations official blue passport paper.

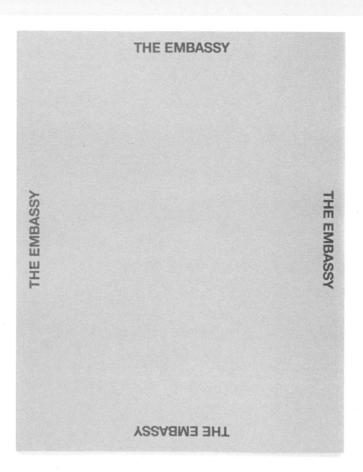

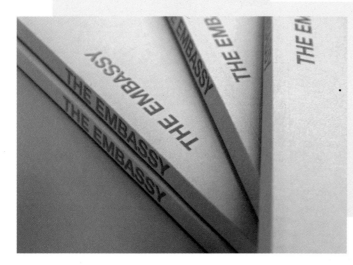

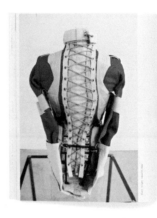
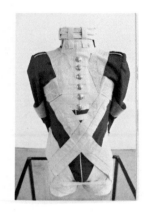

Title
Nathaniel Rackowe Artist Catalogue

Specifications
Size:
A5
Colour & Print:
4-colour, litho
Paper:
cover: pristine white coated paper
inner pages: white uncoated paper
Binding:
perfect bind
Finishing:
laser cut cover

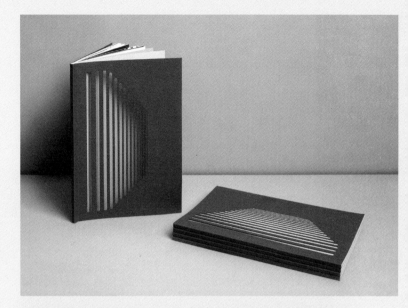

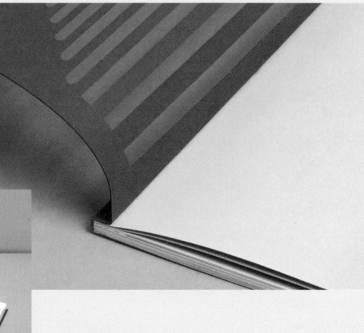

Binding:

PERFECT BIND

:3

Chapter Three:

CHARITY & PUBLIC SECTOR

Charity & Public Sector:

As with all the client sectors in this book, there is no set style when designing for charities. However, working for charities frequently involves larger type sizes for legibility and accessibility. The work by Wire Design provides some interesting examples of attractive design solutions using bigger type size and proves that accessible type doesn't need to be limiting. pp. 115, 132

In design, any work undertaken can become more meaningful when you share the message and passion of your client. It becomes even more rewarding when you see the real impact on people's lives that some charities can make, as well as how design can help them to convey their message and help reach people.

The work done by Studio EMMI for The Prince's Foundation for Children & the Arts is a prime personal example. The studio has designed a number of materials for the Children & the Arts almost from its inception, designing – to give just one example – the organisation's annual reports over several years. Building a relationship with this client over time has given the studio the opportunity to broaden and deepen their creative practice together. p. 136

Title
Don't Believe the Type

Specifications
Colour:
envelope: 2-colours (Pantone)
Paper:
silk coated, 250gsm
Finishing:
envelope: die-cut stencil lettering
contents: T-shirt, stickers, booklet,
badges and a return card

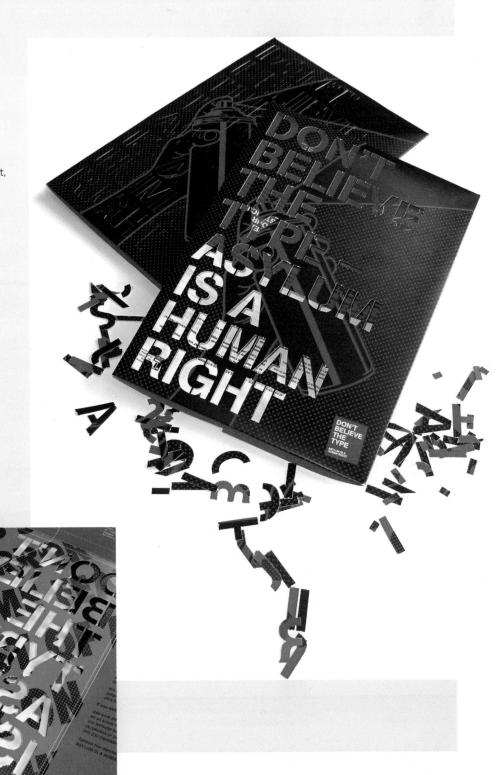

Title
Amnesty Aktion Magazine

Specifications
Size:
310mm x 470mm, 8 pages
Colour & Print:
4-colour, offset
Binding:
saddle stitch

This paper is distributed at
demonstrations and political
events. Each issue contains a
spread that strikingly displays
statistics, in most cases covering
a specific topic. The magazine
illustrates the international
significance of certain processes
with a call for action, inviting the
readers to actively participate.

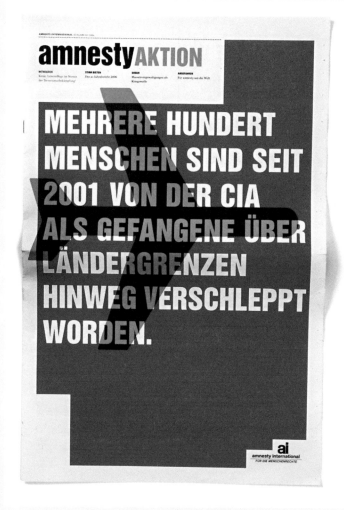

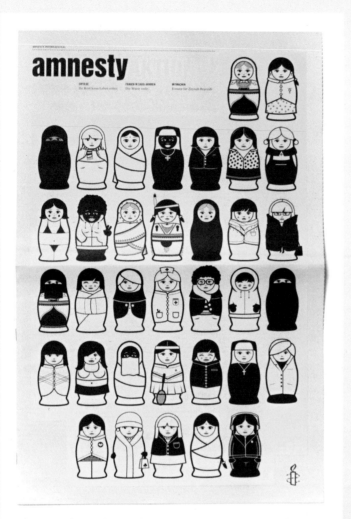

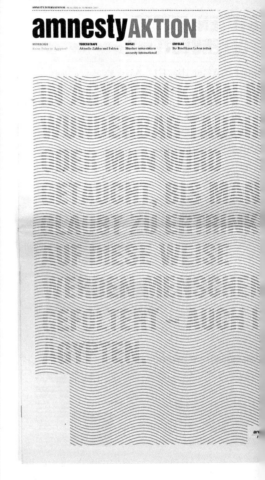

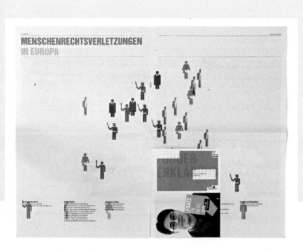

PENTAGRAM SHELTER, UK

Title
House of Cards

Specifications
Size:
card slipcase: 217mm x 177mm
cards and invitation: A5
book: A4, 64 pages plus cover
Colour & Print:
cards: CMYK / 1-colour
invitation: 2-colour
book: CMYK
Paper:
card slipcase: GF Smith Colorplan
Ebony over board
invitation: GF Smith Colorplan Ice
White, 540gsm
book cover: Horizon Offset, 140gsm
book inner pages: Horizon Offset,
300gsm
Finishing:
rounded corners for the cards;
invitation and book foil blocked

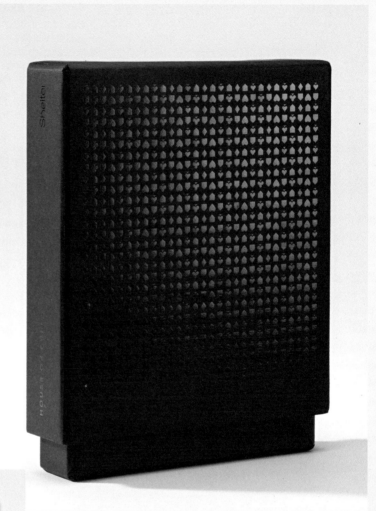

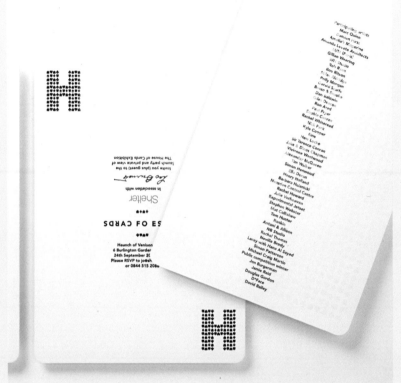

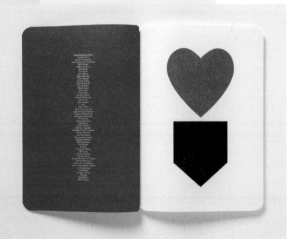

STUDIO EMMI **THE PRINCE'S FOUNDATION FOR CHILDREN & THE ARTS, UK**

Title
MusicQuest Book for Teachers

Specifications
Size:
210mm x 250mm, 48 pages plus
8-page short cover
Colour & Print:
2-colour (Pantone Cyan and Pantone
302), litho printed using vegetable-
based inks
Paper:
cover: GF Smith Colorplan Pristine
White, 270gsm, FSC certified, 100%
ECF virgin fibre, acid free
inner pages: Beckett Expression
Radiance, 118gsm, FSC certified,
100% ECF virgin fibre, made with
wind energy
Binding:
loop stitch

The MusicQuest Book is bound with
loop stitches so teachers can store
it in a durable ring binder, together
with variable A4 student sheets.

Illustrations: Emily Alston

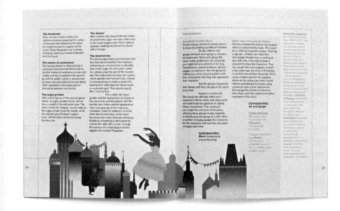

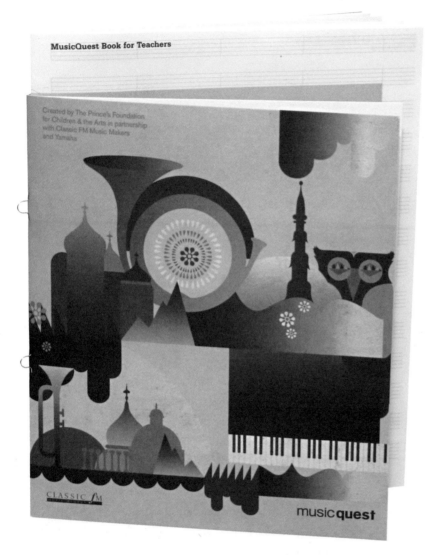

MusicQuest Book for Teachers

Created by The Prince's Foundation
for Children & the Arts in partnership
with Classic FM Music Makers
and Yamaha

CLASSIC FM

music**quest**

<u>Binding:</u>

LOOP STITCH

Title

Drugs – Facing Facts
The Report of the RSA Commission
on Illegal Drugs, Communities
and Public Policy

Specifications

Size:
A4, 336 pages

Colour & Print:
text pages: 1-colour
section dividers: 2-colour, using
vegetable-based inks

Paper:
recycled stock

Binding:
notched perfect bind

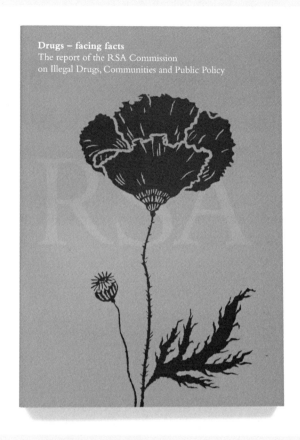

ESPIRELTUS **LUIS SIMARRO, SPAIN**

Title
Tarjeta de Navidad

Specifications
Size:
180mm x 155mm
Colour & Print:
CMYK
Paper:
paper made from chlorine-free pulp
Finishing:
die cut

Illustration by Sergio Montal

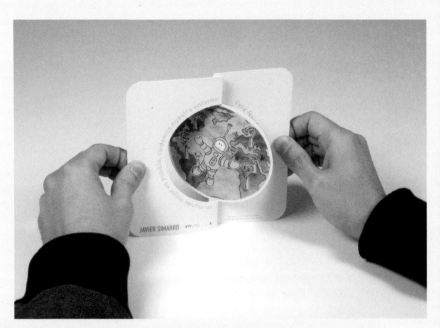

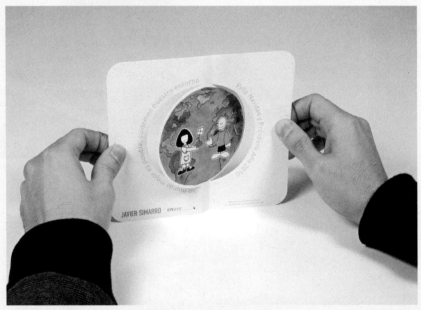

KENN MUNK

WWF (VERDENSNATURFONDEN, DENMARK)

Title
Save the Ice

Specifications
Size:
DIN A4
Colour & Print:
CMYK, by ISO14001 certified
printer
Paper:
Trucard Gloss, 220gsm, FSC
certified
Finishing:
die cut

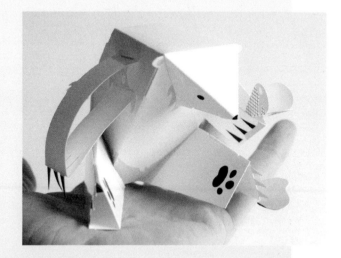

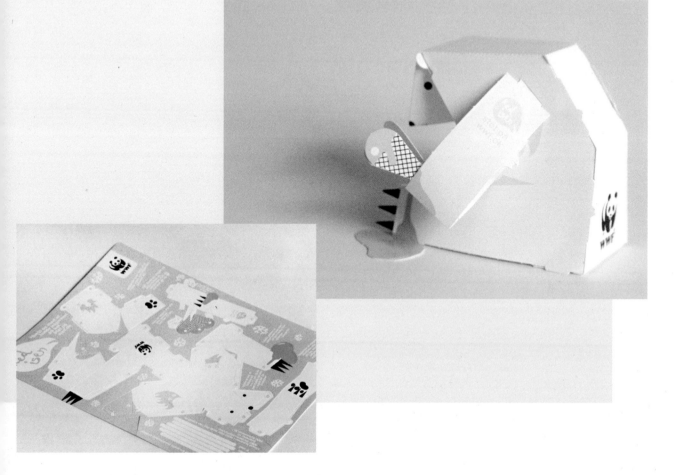

Title
Intermón Oxfam

Specifications
Size:
A2
Colour:
1-colour (black)
Paper:
Pop'Set

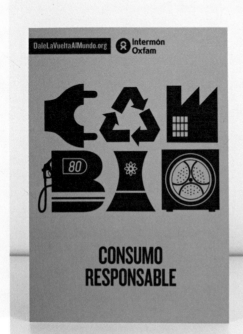

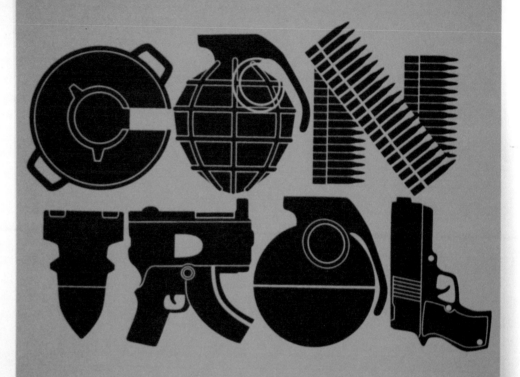

**ARMAS BAJO
CONTROL**

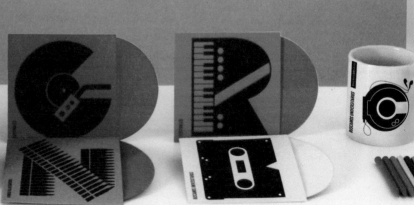

OPTIMASTUDIO

OPTIMASTUDIO, SPAIN

Title
Designs for All

Specifications
Size:
poster: 700mm x 1000mm
Colour & Print:
CMYK plus Pantone
Paper:
Munken Pure, 170gsm
Binding:
casebound book with headbands and
tailbands; green ribbon bookmark
bound into the book at the top of
the spine
Finishing:
poster wrapped around the book
and fixed with a bespoke cloth
measuring tape

Binding:

HEADBAND AND TAILBAND

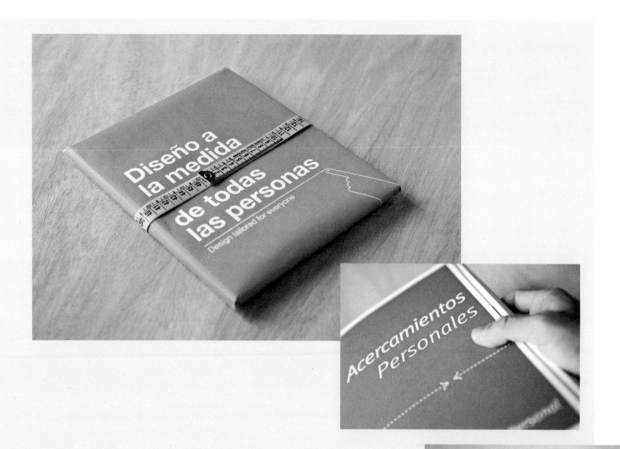

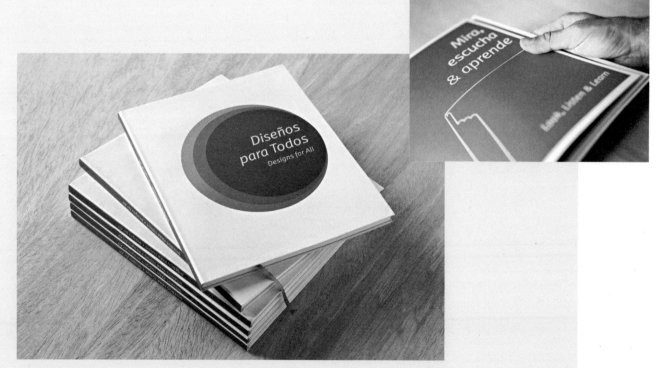

Title
Eurodad Fight Capital Fight campaign

Specifications
Size:
box: 220mm x 320mm
postcards: 20 A6 postcards
report 1: 180mm x 240mm
report 2: A4
Colour & Print:
CMYK plus 2-colour (Pantone metallic and bronze)
Paper:
a selection of Sappi papers
Finishing:
report 2: foil blocked cover

Eurodad is a network of 54 European NGOs working to change development finance policies and to ensure that poorer people influence decisions that affect their lives. Fight Capital Flight campaign informed decision makers about the multiple aspects of the north/south financial gap. The campaign included a fact box with a memorandum manifesto, facts postcards and three poverty/luxury posters.

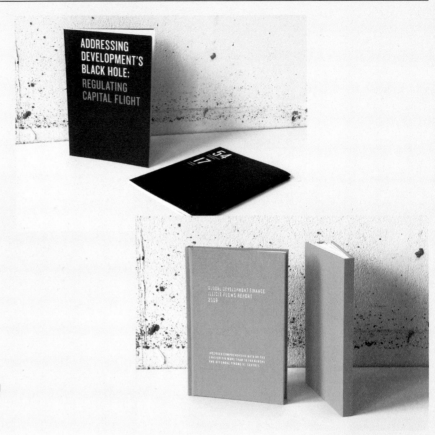

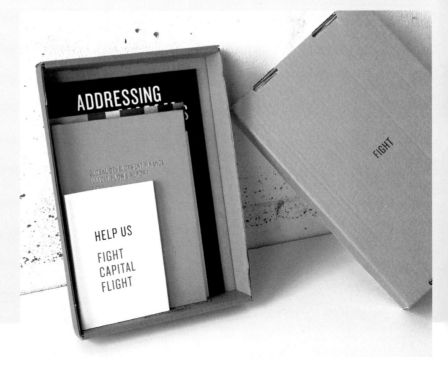

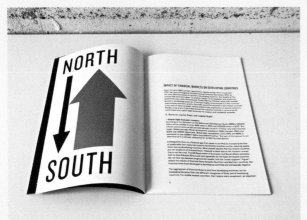

IMPACT OF FINANCIAL MARKETS ON DEVELOPING COUNTRIES

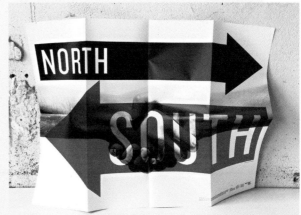

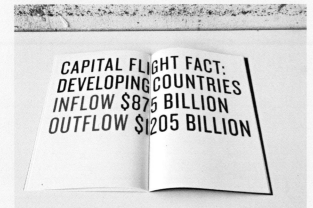

CAPITAL FLIGHT FACT:
DEVELOPING COUNTRIES
INFLOW $875 BILLION
OUTFLOW $1205 BILLION

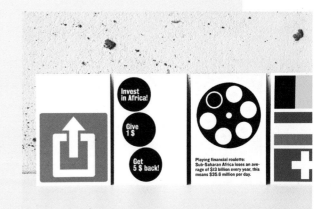

Invest in Africa!

Give 1 $

Get 5 $ back!

Playing financial roulette: Sub-Saharan Africa loses an average of $13 billion every year, this means $35.6 million per day.

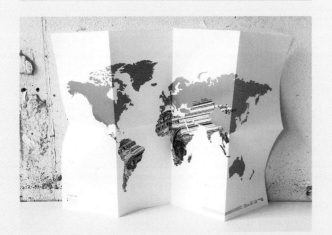

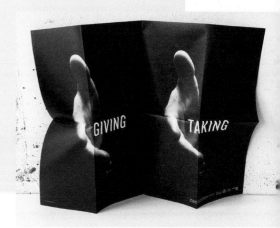

GIVING TAKING

WIRE EMPLOYER'S FORUM FOR DISABILITY, UK

Title
Unravelling the Knot Invite

Specifications
Size:
A5
Colour:
1-colour
Paper:
GF Smith Colorplan, 350gsm
Folding:
A4 folded to A5
Finishing:
foil blocking

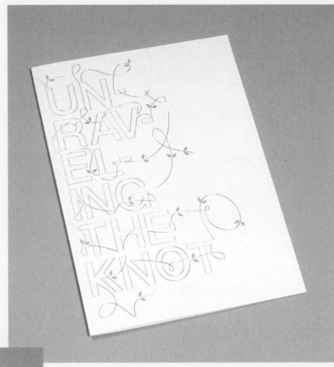

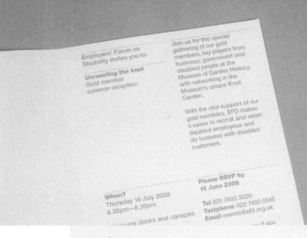

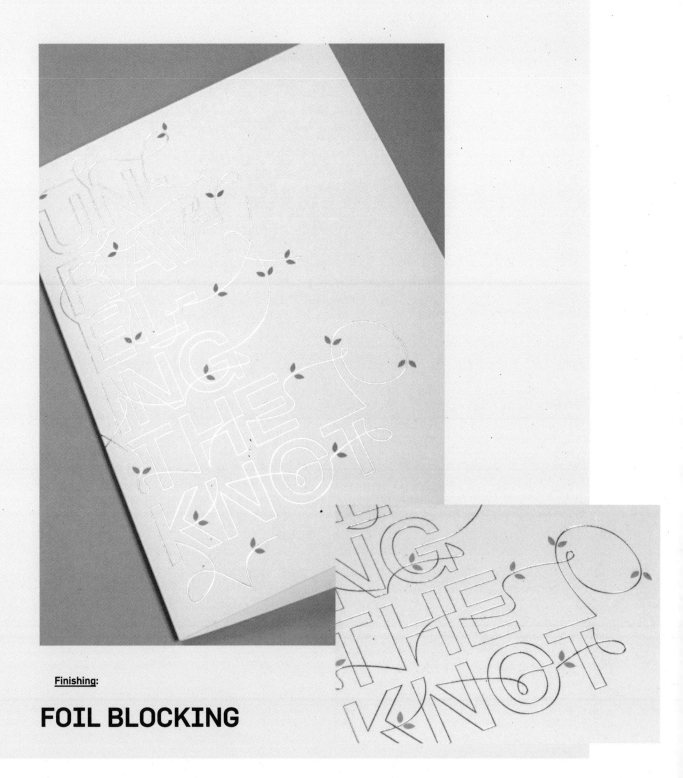

FOIL BLOCKING

Title
Sustainable Christmas Card

Specifications
Size:
A5 card that folds out to A3 poster
Colour & Print:
CMYK
Paper:
100% recycled

As an example of a multi-purpose
sustainable approach, the logo
can be peeled off, turning the poster
into Christmas wrapping paper.

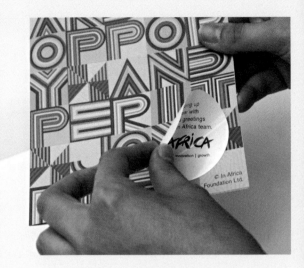

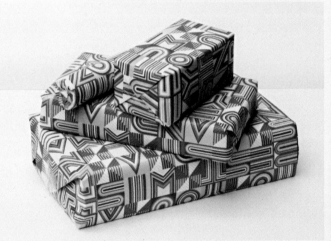

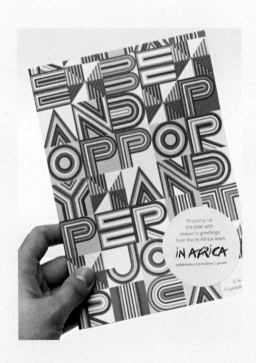

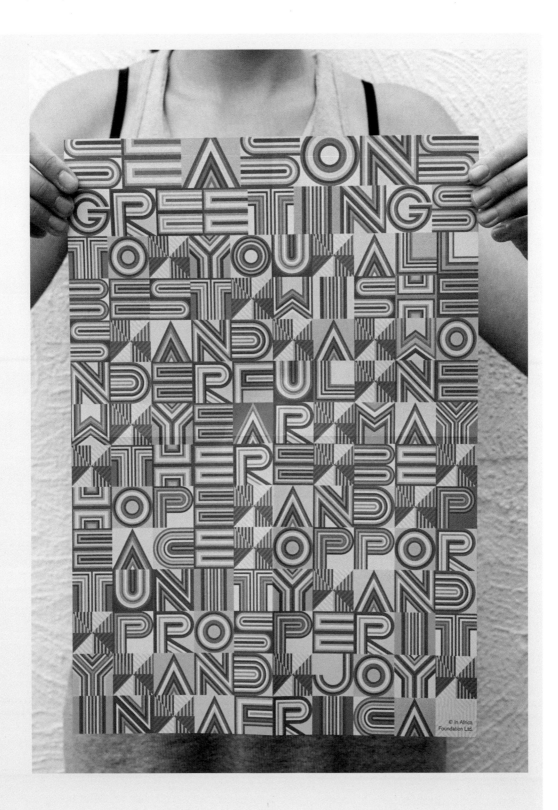

Title
Annual Reviews:
2006/7, 2007/8 and 2008/9

Specifications
Size:
A5, 32 pages
Colour & Print:
cover: 2-colour (Pantone Magenta and Pantone 229)
inner pages: CMYK, vegetable-based inks
Paper:
2006/7
cover: Gmund Bier Weizen
inner pages: Revive 50-50 Offset
2007/8
cover: Metaphor
inner pages: Context
2008/9
cover: Corona Offset, 300gsm
inner pages: Emerald Repro, 115gsm
Folding:
2008/9: back cover flap folded over fore-edge
Binding:
perfect bind

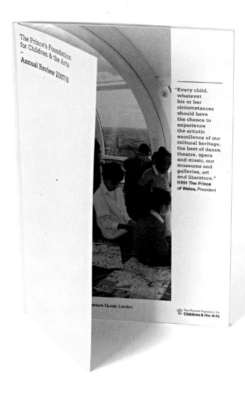

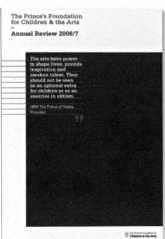

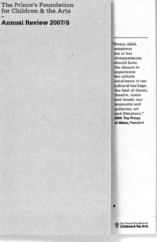

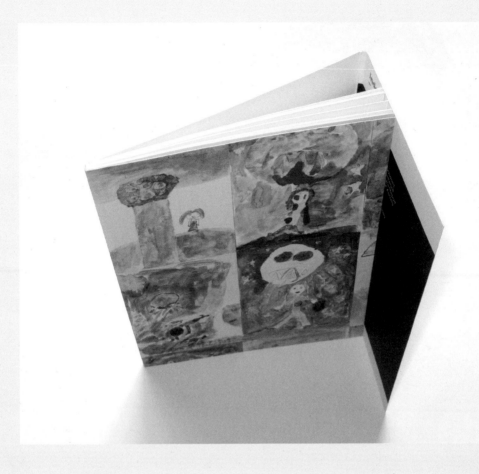

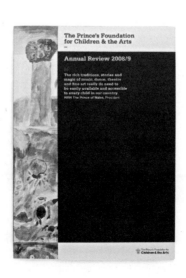

Title
Renaissance: The Revitalisation
of Elephant & Castle

Specifications
Colour:
inner pages: 5-colour
Paper:
dust jacket: GF Smith Colorplan
cover: GF Smith Colorplan
inner pages: Satin, 150gsm
Finishing:
UV varnish on inner pages;
embossing and 2-colour
foil blocking on dust jacket

Renaissance revitalisation:
The Elephant & Castle
of Elephant

Introduction
Past
Present
Future

Contents

LUCIENNE ROBERTS + **PANOS LONDON, UK**

Title
Growing Pains: How Poverty and
AIDS Are Challenging Childhood

Specifications
Size:
210mm x 160mm
Colour & Print:
cover: 1-colour, silkscreen
pages 1-216: 1-colour
pages 217-236: CMYK
pages 237-252: 1-colour
Paper:
cover: 2mm strawboard
pages 1-216: Cyclus offset, 100gsm
pages 217-236: Cyclus offset,
140gsm
pages 237-252: Cyclus offset,
100gsm
Binding:
section sewn with coloured
cloth spine and affixed front
and back covers

Design: Lucienne Roberts/
John McGill

This engaging book, commissioned by the Bernard van Leer Foundation, brings new perspectives to the debate about AIDS by relating the experiences of young children in South Africa, as well as some instances in Tanzania and Kenya. First-hand accounts of children, caregivers and community workers illuminate efforts to bridge the gulf between policies based on children's rights and the experience of millions of young children.

Anthony Swift and Stan Maher's in-depth and candid accounts of grassroots interventions emphasise the importance of early childhood development. They draw attention to basic needs that are often unmet amid the endemic challenges of sickness, poverty and stigma.

The authors explore the mutual support provided by children, families, community members and local organisations and argue that this local reciprocity is increasingly under threat.

PANOS LONDON ILLUMINATING VOICES

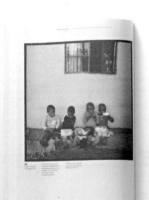

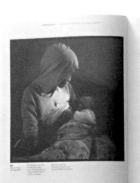

Title
Showing Expectations

Specifications
Size:
155mm x 215mm
Colour:
1-colour (black)
Paper:
cover: Dutch greyboard, 300gsm,
EFC certified
dustjacket and inner pages:
Pop'Set, 120gsm

A visual arts project titled 'Showing:
Expectations' invited six Leeds-
based community groups, which
are identified on educational
and organisational databases as
being under-represented in higher
education and the creative sectors,
to participate in and curate their
own art exhibition. The community
groups involved were: Workers'
Educational Association,
St Anne's Resource Centre & Open
Learning, Gypsy Roma Traveller
Achievement Service Leeds,
Emmaus – Leeds Community, South
Leeds Health for All Asian Elders
and St George's Crypt.

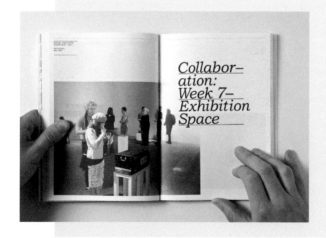

Showing: Expectations
A collaborative arts project in Leeds
Edited by Leonor da Silva & Sue Wilks

www.showingexpectations.co.uk

<u>Format:</u>

DUST JACKET

TANGENT GRAPHIC **SCOTTISH HUMAN RIGHTS COMMISSION, UK**

Title
Annual Report

Specifications
Size:
A4, 36 pages
Colour & Print:
CMYK
Paper:
Revive Pure White 100%,
recycled stock
Binding:
saddle stitch
Finishing:
laser cut cover

Title
Annual Report and 6 Accounts

Specifications
Size:
A2, 24 pages
Colour & Print:
CMYK
Paper:
Arctic Volume White, 100gsm,
FSC certified
Folding:
A2 folds to A3
Binding:
self-cover, loose-leaf document
Finishing:
sent out in polybag

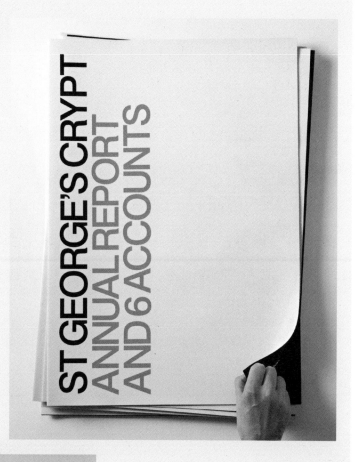

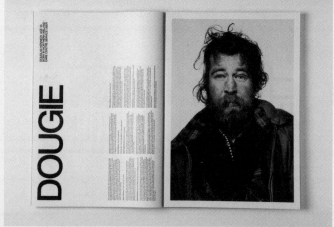

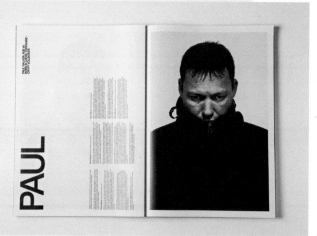

Title
Catalyst

Specifications
Size:
A4, 124 pages
Colour & Print:
CMYK, vegetable-based inks
Paper:
cover: Munken Print White, FSC
certified
inner pages: Arctic Volume White,
FSC certified
Binding:
perfect bind
Finishing:
Includes a bookmark with a fold

Illustrations by Lucy Vigrass

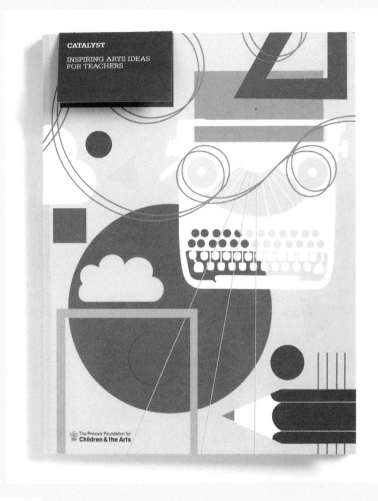

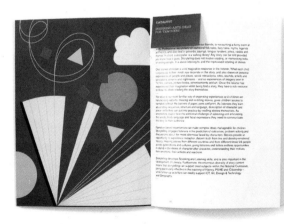

Chapter Four:

CULTURE

The designs showcased in this chapter are made for a wide client list, and bears the title 'Culture' as a catch-all for those inspiring projects that are not otherwise easily catalogued.

Case studies such as the posters and flyers designed by Julia for Invisible Dot, a London-based comedy production company, include some exemplary cost effective design solutions. Invisible Dot constantly needs documents to be made quickly at a low cost and quantity. Julia's solution was to use Risograph printers and design a distinctive typeface, Riso, which would establish the identity while also answering the brief beyond the client's expectations. p. 172

Another example of a resource saving, environmentally friendly design solution is by This Is Real Art for the International Society of Typographic Designers' *Typographic 65* magazine. Titled 'The Advertising Issue', it persuaded the designer Paul Belford to print the majority of the magazine onto distinctive blue backs of randomly trimmed, unused advertising posters, paper that otherwise would have been pulped. This created a series of random alternate spreads throughout the magazine, making each magazine unique. p. 170

Title
(p)review

Specifications
Size:
A5, 32 pages
Colour & Print:
cover: short cover, flush at foot
only, no print
front and back section:
2-colour (Pantone)
middle section: CMYK,
vegetable-based inks
Paper:
cover: Keaykolour Antique Seal
front and back section:
Keaykolour Recycled May
middle section: Chromomat
Binding:
saddle stitch
Finishing:
die cut slots for business card

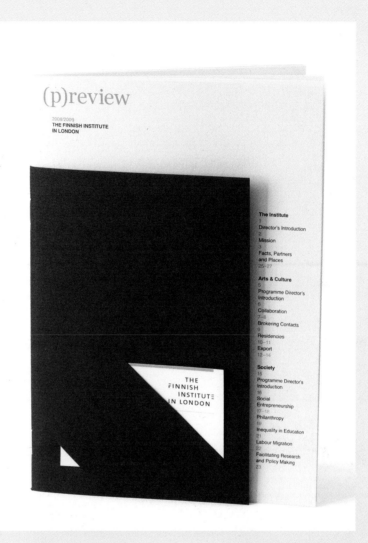

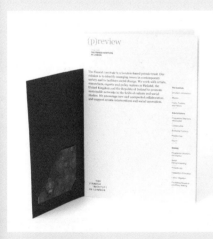

Finishing:

DIE CUT

FORM **ARTS & BUSINESS, UK**

Title
29th Arts & Business Awards
Brochure

Specifications
Size:
170mm x 255mm, 32 pages
Paper:
Plike
Binding:
saddle stitch
Finishing:
high-gloss laminate finishes and
foil blocking; the cover features a
wraparound flap with silver and
white foil blocking; the back of the
flap has perforated swatches that
were torn off for voting slips

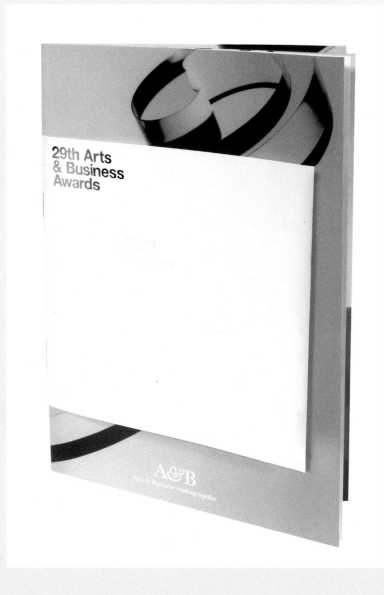

Ogilvy Arts &
Business
Creativity
Award

Arts & Business aspires to be
the world's most successful
& widespread creative network.
We help business people support
the arts & the arts inspire
business people, because good
business & great art together
create a richer society.

Celebrating
a future built
on ideas and
creativity

Arts & Business
Community
Award

Design Client

WORLDSTUDIO **THE FASHION CENTER BUSINESS IMPROVEMENT DISTRICT, USA**

Title
A Stitch in Time: A History of New
York's Fashion District

Specifications
Size:
7" x 10", 28 pages plus cover
Colour:
3-colour (Black, PMS Yellow
and PMS 424U)
Paper:
Mohawk Navajo Brilliant
Binding:
singer sewn through
Finishing:
coating throughout

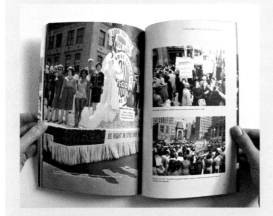

Binding:

SINGER SEWN THROUGH

VIA GRAFIK HESSISCHES LANDESTHEATER MARBURG, GERMANY

<u>Title</u>
Inthega Brochure

<u>Specifications</u>
<u>Size</u>:
210mm x 210mm, 36 pages
<u>Colour & Print</u>:
CMYK, offset
<u>Paper</u>:
offset paper, 110gsm
<u>Binding</u>:
saddle stitch

Photos by Margaritha
Brenner-Grigorowa

JORGE LORENZO CONSEJERÍA DE CULTURA DEL PRINCIPADO DE ASTURIAS, SPAIN

Title
XX Muestra de Artes del Principado
de Asturias

Specifications
Size:
A5, 128 pages
Colour & Print:
CMYK and duotone
Paper:
Plaster Velvet 2000 Vol Creator
Binding:
perfect bind
Finishing:
dust jacket

Print:

DUOTONE

Title
Personen, Profile, Perspektiven

Specifications
Size:
148mm x 210mm
poster, flat: 564mm x 840mm
poster, folded: 150mm x 210mm
Colour & Print:
1/4, offset
Paper:
Chromolux 700, 180gsm / 90gsm
poster: z-pharma, 50gsm

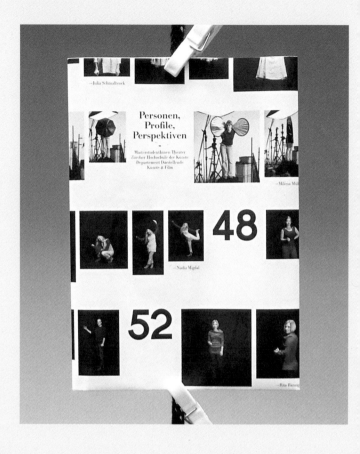

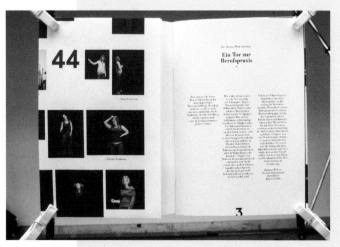

Title
Masterplaner

Specifications
Size:
flat: 594mm x 420mm
folded: 148mm x 210mm
booklet insert: 105mm x 148mm
Colour & Print:
CMYK plus 1-colour (black), offset
Paper:
Munken Print Cream, 90gsm
Muskat Brown Paper, 100gsm
Econocolor Pink, 65gsm
Luxart gloss, 100gsm
Binding:
saddle stitch with red wire

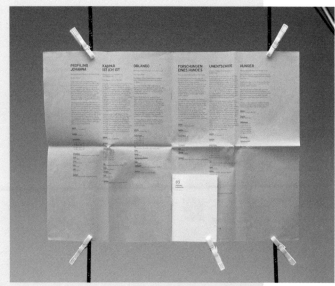

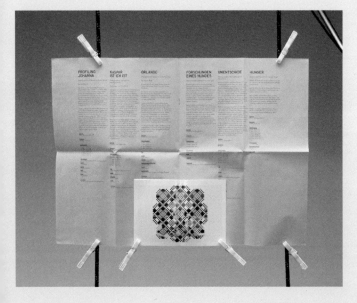

MARKO JOVANOVAC OSJECKO LJETO KULTURE, CROATIA

Title
Završnica / Endgame

Specifications
Size:
flat: 630mm x 420mm
folded: 330mm x 145mm
Colour:
2-colour (black and red)
Paper:
Vega, 90gsm
Folding:
manually folded six times

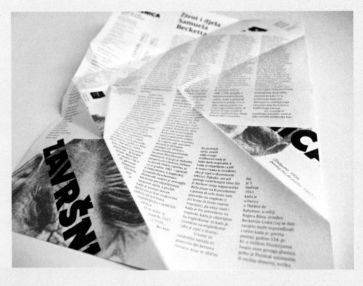

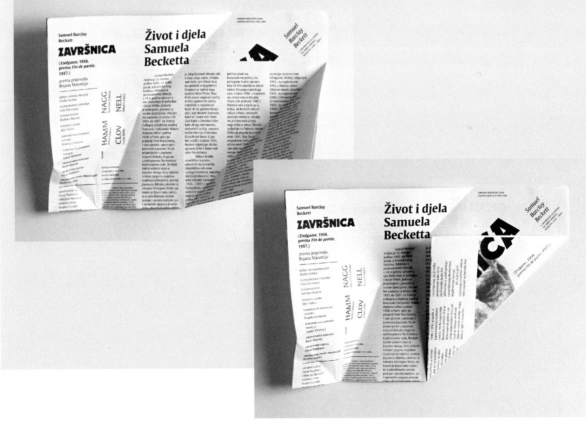

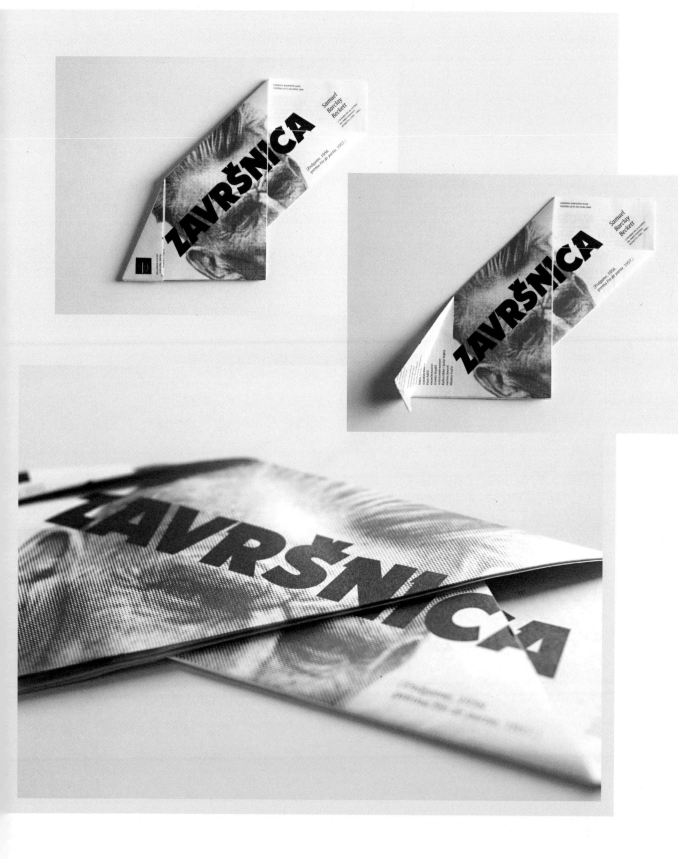

Title
Teatre Principal d'Olot

Specifications
Size:
leaflet: A3 folded to A6
programme: A6, 60 pages
Colour & Print:
2-colour
Paper:
Antalis Popset, different colours

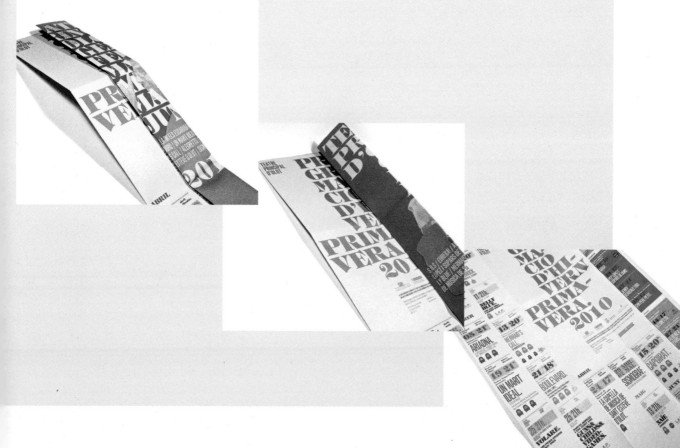

FRASER MUGGERIDGE STUDIO CRAFTS COUNCIL, UK

Title
Collect Leaflets

Specifications
Size:
8-page leaflet
Colour & Print:
CMYK plus 2-colour
Paper:
coated and matt
Folding:
the first panel falls short,
enabling the two different sides
of the paper to be combined on
the front of the leaflet

EN PUBLIQUE **PROJECTBUREAU BELVEDERE, THE NETHERLANDS**

Title
Radio Kootwijk Frequency

Specifications
Size:
240mm x 170mm, 64 pages
Colour & Print:
3-colour (black, grey PMS and
metallic PMS)
Paper:
cover: Hello silk, 350gsm
inner pages: Hello silk, 150gsm
Folding:
double folded cover
Binding:
sewn sections

Title
DREBBEL

Specifications
Size:
216mm x 171mm, 112 pages

Colour & Print:
2-colour (PMS Black and PMS 485c), offset

Paper:
Pioneer 'Wood-Free' Offset, 110gsm
Cyclus Recycled Offset Paper, 80gsm

Binding:
sewn sections with open-spine stitch

Finishing:
hand-stamped imprints and handmade felt bookcasing

Finishing:

RUBBER STAMP

B&W STUDIO **LEEDS YOUTH OPERA, UK**

Title
Der Freischutz Flyer

Specifications
Size:
210mm x 148mm, landscape
Colour:
1-colour (black)
Paper:
GF Smith Colorplan, Gmund
Bier, Plike, Nomad (Omar),
Heartland, 350gsm
Finishing:
shot by a hi-powered rifle
from distance

Leeds Youth Opera
Presents
Der Freischütz
By Carl Maria von Weber

THIS IS REAL ART INTERNATIONAL SOCIETY OF TYPOGRAPHIC DESIGNERS, UK

Title
Typographic 65
The Advertising Issue

Specifications
<u>Size</u>:
297mm x 210mm, 92 pages
<u>Colour & Print</u>:
CMYK
<u>Paper</u>:
printed mostly on blue backs
of randomly trimmed, unused
advertising posters, making
each magazine unique
<u>Binding</u>:
thread-sewn section with
dust jacket

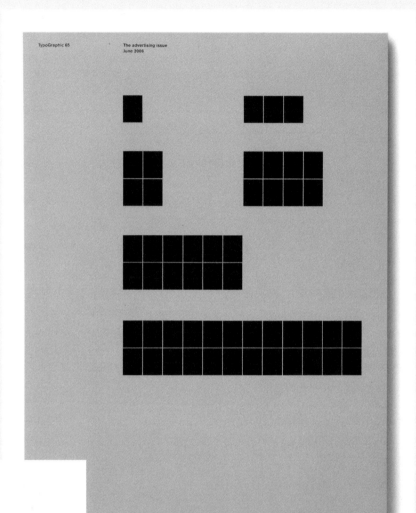

JULIA

THE INVISIBLE DOT, UK

Title
The Invisible Dot

Specifications
Size:
varied
Colour & Print:
1-colour and 2-colour, risograph
Paper:
various

The Invisible Dot, a comedy
production company and venue
in London, needed posters and
flyers to be made quickly at low
cost and quantities. The solution
was to use Risograph printers and
create a distinctive typeface that
would establish the identity. The
resulting type, Riso, has alternative
characters with different widths
to help the composition.

Wednesday
08.09.09
8pm

DANIEL
KITSON

WE ARE
GATHERED
HERE

Wednesday
22.09.09
8pm

GHOST
GHOST
GHOST
GHOST
WATCH

Thursday
25.06.09
7pm

JON
RICHARDSON
DAN
ATKINSON
LLOYD
LANGFORD
THE DOT
FARM

Wednesday
29.09.09
8pm

ZELIG
ZE ZELIG
ZELIG
ZE
WOODY ALLEN

Wednesday
15.09.09
8pm

THE
FALLS

PETER
GREENAWAY

Design **Client**

B&W STUDIO LEEDS YOUTH OPERA, UK

Title
Idomeneo Programme

Specifications
<u>Size</u>:
poster: 470mm x 670mm
book: 168mm x 224mm, 32 pages,
self-cover
<u>Colour</u>:
1-colour (black)
<u>Paper</u>:
poster: Chromolux White Label,
120gsm
book: Colorit Kingfisher Blue,
120gsm
<u>Folding</u>:
poster wraps around the book
as dust jacket
<u>Binding</u>:
saddle stitch

D&W STUDIO ROYAL INSTITUTE OF BRITISH ARCHITECTS, UK

Title
RIBA Architects Awards

Specifications
Size:
images: A5, 8 pages
text: A6, 16 pages
Colour & Print:
CMYK plus fluorescent pink
spot colour
Paper:
Arctic Volume Matt, 100gsm
Binding:
smaller brochure slides into the
reverse of the larger brochure

WHITE R A 2

RIBA Yorkshire Team 2009

RIBA Yorkshire region covers Yorkshire and the Humber and is directed by a Council elected from amongst its architect members. There are just over 2000 members in the region, which is divided into nine local branches.

The RIBA regions fulfil a vital co-ordinating role between RIBA members and the public. We provide core services for members and administer key RIBA strategies. We promote architecture and RIBA architect members through events

and initiatives such as the awards schemes, CPD, regeneration debates, seminars, networking events and exhibitions.

Our office is based on The Calls, in the heart of Leeds design quarter and we share a beautifully converted Victorian riverside warehouse with built environment partners, architect practices and chartered surveyors.

Regional Team
(from left to right)
Geoff Ward
Regional Chair
Emma England
Regional Director
Claire Hutchinson
Marketing and Events Officer
Denise O'Toole
Membership and
Branch Liaison Officer

Regional Executive
David Smith
Vice Chair
John Orrell
Regional Treasurer
Robin Parker
Regional Secretary
Ian Collins
National Councillor
Gerard Bareham
National Councillor

Title

175 Years Rickmers

Specifications

Size:

folder: A4

booklet: A5, 36 pages

Colour:

2-colour (Pantone 876 U and Black)

Paper:

cover: Gmund Colors Subtil 50,
310 gsm, FSC certified, Gmund ECO
certified

inner: Gmund Colors 50, 135gsm,
FSC certified, Gmund ECO certified

Binding:

booklet: saddle stich

Finishing:

Paperlux™ paper etching

Binding:

PAPERLUX™ PAPER ETCHING

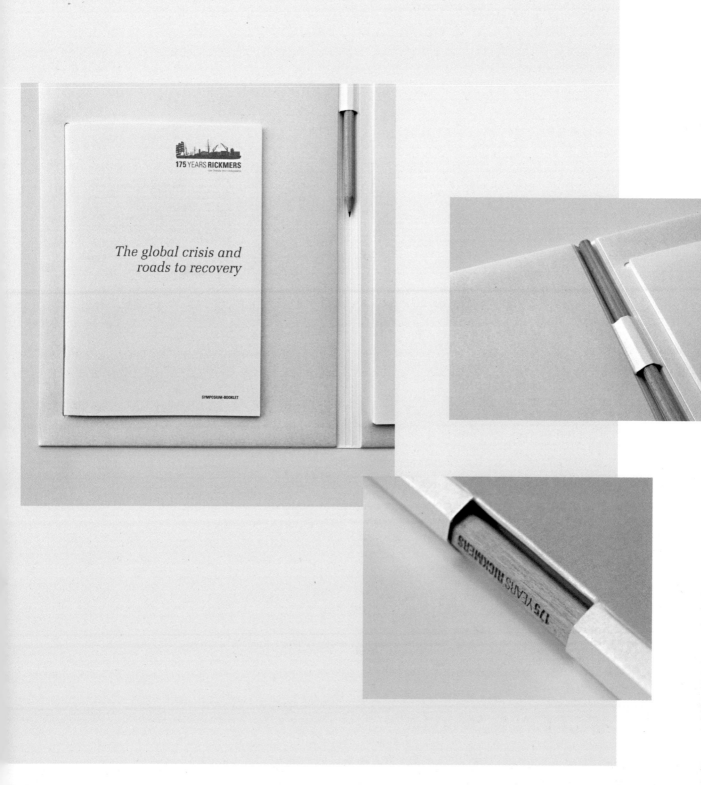

Title
Publicación cultural sobre los derechos y normas aplicables al turista

Specifications
Size:
150mm x 215mm, 42 pages
Colour:
1-colour (black)
Paper:
three different coloured paper stocks, all recycled
Finishing:
screw binding

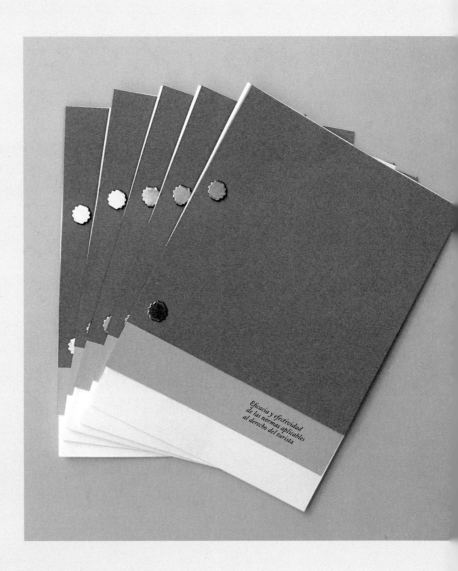

Binding:

SCREW BINDING

Design Client

MIND DESIGN **PLAYLAB, UK**

===

Title
Playlab Identity and Stationery

Specifications
<u>Colour</u>:
4 spot colours
<u>Paper</u>:
recycled paper stock
<u>Finishing</u>:
blind embossing, rubber
stamped details

<u>Format</u>:

BLIND EMBOSSING

Title
Awards Annual

Specifications
Size:
250mm x 250mm, 500 pages
Colour & Print:
CMYK
Binding:
case bound, sewn sections
Finishing:
cover: drill holes and 4 foils

The cover idea came from the branding — a creative circle is a square. Because the book is an awards annual, the cover design took the form of a target. The various levels of awards are represented by foils — gold, silver, bronze and white for in-book. To further dramatise the target idea, holes have been drilled into the cover board.

Binding:

CASE BINDING

DESIGN & THE ENVIRONMENT

As demonstrated throughout this book, being environmentally conscious as a designer can be rewarding on many levels. Here are a few pointers of what to consider at various stages in the creative process.

Design:

Perhaps the most valuable part of the process is planning. There are a number of things you can do to reduce waste and costs during the design process by making conscious decisions on the following: the size of your item, the weight of the paper used, its planned life cycle (could it be easier to update, for example), and possibilities for multi-purpose uses. Equally important to the creative process is proofing the design thoroughly for any mistakes, therefore avoiding reprints and, of course, disappointments.

Print:

Being on good terms with your printer is vital, and the more you understand of the printing process the more creative you can be with your solutions. It is a good idea to get a printer involved with a project from early on. Using a local printer will help with reduced transport costs and emissions. Before sending the work to the printers, make a mock-up of the item in the studio. Seeing the design printed often shows mistakes that would be easy to miss onscreen.

Perhaps you have more than one project ready to print at the same time, maximising the use of inks, paper and energy. Even better, plan to make this the case. Print with vegetable-based inks if possible and make a considered choice when choosing metallic inks and foil blocking, as these may make the finished product impossible to recycle. Check your printer's green credentials for FSC certification and ISO14001.

Studio environment:

Design studios are like homes, not only in a sense of the time spent there but also in terms of the environmental choices we can make. There are green choices available for all aspects, including lighting, furniture, cleaning, heating and use of energy in general.

On top of the materials that we recycle at home, like milk cartons and newspapers, in a studio we can also find schemes to recycle CDs, DVDs (better still to eliminate these altogether and transfer files online), ink cartridges, computers, and all the paper (that you've used and used again and on both sides already, naturally).

From how we commute to work each day to what online hosting services we have chosen to use, all aspects can become part of a studio's environmental design ethos.

GLOSSARY

4/1:
One side of the sheet is printed in 4-colour and the other side is printed in 1-colour. Images and text are distributed according to the placement of 4-colour and 1-colour pages. This means the printing is more economical, as the book appears to be in colour, but half of it is in black and white.

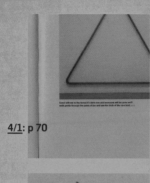

4/1: p 70

4-COLOUR-PROCESS:
The process of combining four process colours – cyan, magenta, yellow and black – to create a printed full-colour picture or to create colours composed from these four colours. See also: CMYK.

blind emboss: p 182

BLEED:
A printed image or colour that extends past the trimmed edges of the page.

BLIND EMBOSS:
Blind embossing uses no foil when pressing the paper, creating a raised impression.

CASE BINDING:
The traditional binding process of making hard cover books, in which the book case (cover) is made separately from the text block and later attached to it.

CMYK:
CMYK (cyan, magenta, yellow, black) are the subtractive primaries, or process colours, used in printing. The printing process itself can also be described as CMYK.

DIE CUT:
Specially made shapes are cut into a paper or card using a steel die.

DIGITAL PRINTING:
Digital printing doesn't require printing plates, which means less waste and chemicals. Every digital print can be different, making it the economical choice for smaller print runs and one-offs.

DUOTONE:
Duotone image uses two colours only.

case binding: p 184

die cut: p 149

duotone: p 154

DUST JACKET:
Dust jacket is a loose outer paper wrap. It has folded flaps that hold it to the front and back book covers. Also known as a book jacket, dust wrapper or dust cover.

EMBOSS:
Embossing creates a raised image by pressing a shape into a sheet of paper with a metal or plastic die.

ENDPAPER:
Endpapers are the papers that attach a book block to the covers. These are glued onto the front and back inside covers.

FORE-EDGE:
Fore-edge is the part of a book opposite and parallel to the spine.

FULL BLEED:
A page that has an image that prints all the way to edges on all four sides. See also: Bleed.

dust jacket: p 142

full bleed: p 134

FOIL BLOCKING:
A technique to apply an image or text to paper or board using foil and a heat die.

FSC:
FSC (Forest Stewardship Council) is an independent, non-governmental, not-for-profit organisation established to promote the responsible management of the world's forests. FSC has developed principles for forest management of forest holdings, and a system of tracing, verifying and labelling timber and wood products, which originate from FSC certified forests.
www.fsc.org

FSC CHAIN OF CUSTODY:
FSC Chain of Custody (CoC) tracks FSC certified material through the production process – from the forest to the consumer, including all successive stages of processing, transformation, manufacturing and distribution. The FSC label provides the link between responsible production and consumption and thereby enables the consumer to make socially and environmentally responsible purchasing decisions.
www.fsc.org

foil blocking: p 84

FRENCH FOLD:
The method of folding a sheet of paper in half and binding along the open edges. A french fold brochure is made by folding a page in half in one direction and then folding the folded page in half again in the opposite dimension.

HALFTONE:
A process used to reproduce an image through the use of dots varying either in size or in spacing, to simulate tonal range.

HEADBANDS AND TAILBANDS:
A functional and/or ornamental cloth tapes at the top and bottom of a book, between the spine and book block.

ISO 14001:
The ISO 14001 is a family of internationally-recognized standards for environmental management systems that is applicable to any business or organisation, regardless of size, location or income. These standards are developed by the International Organization for Standardization (ISO).
www.iso.org

french fold: p 104

headbands: p 128

LASER CUTTING:
A precise method of cutting that uses a laser to cut materials. Laser cutting allows elaborate and tiny shapes to be cut out of paper.

LETTERPRESS:
A traditional method of printing type, using a surface with raised letters (metal or wood) which is inked and pressed into the paper. The type debosses the paper in the process.

LOOP STITCH:
An alternate saddle-stitch binding method in which the staples are formed into wire loops, allowing a saddle-stitched publication to be bound in a standard 3-ring binder. They can also be customplaced for any 2-hole or 3-hole ring system.

loop stitch: p 120

OFFSET:

Offset printing is a commonly used printing technique where the inked image is transferred (or "offset") from a plate to a rubber blanket, then to the printing surface.

PAPERLUX™ PAPER ETCHING:

Paperlux™ patented paper etching with bundling light creates pin-sharp, three-dimensional engravings on finest paper without hurting it's reverse side. The method removes defined parts of the upper layer in different depths and creates delicate relief in an unknown precision. This environmentally friendly techinique uses no colours, solvents or other materials, just light.

paperlux™ paper etching: p 178

PEFC:

PEFC (Programme for the Endorsement of Forest Certification Schemes) is an international, not-for-profit organisation that is primarily made up of representatives of the forest products industry. Unlike the FSC, it does not set specific standards but is an umbrella brand that incorporates different national forest certification schemes. This is intended to make the forest certification easier and more applicable to different types of forests.

www.pefc.org

PERFECT BIND:

A type of binding that glues the edge of individual sheets on the spine with glue.

PERFORATED PAPER:

Paper with regularly punched holes. It is also sometimes referred to as punched paper.

PMS:

PMS (Pantone Matching System) is is the most well known system of spot colours. It provides designers with swatches for specifying the match colours and gives printers the recipes for making them.

POST-CONSUMER WASTE:

Post-consumer waste is the recovered, recycled material a consumer has used and disposed of. There are recycled paper grades that range from 10% post-consumer to 100% post-consumer recycled.

perfect bind: p 112

perforated paper: p 102

PRE-CONSUMER WASTE:
Pre-consumer waste is generated during the paper-making process, it's material that never reached the consumer. This waste can be from the mill or paper waste from the printers, such as off-cuts, that is returned to the mill for use as a pulp substitute. There are recycled paper grades that range from 10% pre-consumer to 100% pre-consumer recycled.

PRINT ON DEMAND:
Digital print on demand is used as a way of printing items when required, for a fixed cost per copy, irrespective of the size of the order (which can be as low as one).

QUARTER BIND:
A book with its spine bound in a different material than the boards, so that the material on the spine wraps approximately one-quarter of the way around the front and back cover.

REAM:
500 sheets of paper.

148 x 210

print on demand: p 42

quarter binding: p 62

RECYCLED PAPER:
Recycled paper is a broad term with multiple variations. In simplified terms, recycled paper is a grade of paper that contains recycled (post-consumer and/or pre-consumer) fibre, defined by percentages.

RGB:
RGB stands for the three primary colours of light – red, green and blue. The computer's native colour space for capturing images and displaying is refered to as RGB.

RUBBER STAMP:
A stamp, usually made of rubber, that is inked and used for imprinting a design on another object by hand.

SADDLE STITCH:
A common method of binding where the cover and pages are bound together using stitches or wire staples on the centerfold.

recycled paper: p 60

rubber stamp: p 166

saddle stitch: p 72

Inva

SCORE:
A creased line in a sheet of paper that will allow folding at a specific point. It also helps to prevent cracking on the folds.

SEWN SECTION:
Also known as "thread-sewn section". A book in which each signature is sewn and then collated with other signatures and sewn together before binding.
See also: Signature.

SHEET-FED PRESS:
A printing press that prints individual sheets of paper as opposed to rolls.

SCREW BINDING:
A method of binding where the pages are kept together using bolts inserted through drilled holes and secured on the reverse side.

SIGNATURE:
A sheet with several pages printed on it; it folds to page size and is bound with other signatures to form a book.

sewn section: p 52

screw binding: p 180

SILKSCREEN:
Otherwise known as screenprinting, silkscreen is a printing method where ink is passed through a screen containing an image and onto a substrate.

SINGER SEWN:
The binding of a book using an industrial sewing machine, sewing along the binding edge.

SINGER SEWN THROUGH:
The binding of a book using an industrial sewing machine, sewing through the front of a book to the back.

SOY-BASED INKS:
Inks derived from soy bean oil instead of petroleum products, thus being easier on the environment. One of many vegetable-based inks.

SPINE:
The bound edge of a book.

silkscreen: p 57

singer sewn through: p 152

SPOT COLOUR:
Any specific ink not generated by the 4-colour process method. The Pantone Matching System (PMS) is the most well known system of spot colours used in graphic design.

SPOT UV VARNISH:
UV varnish applied to chosen areas of a printed piece.

SWISS BINDING:
With Swiss binding, the cover is not attached to the face top edge, completely detached and the binding edge has an attractive cloth lining enclosing the sheets together. This is another form of perfect binding.

THREE-HOLE SEWN:
A handmade binding method where binding thread is sewn into the spine through three holes and is fastened with a knot on the inside.

THREAD-SEWN:
See: Sewn Section.

three hole sewn: p 69

UV VARNISH:
UV (ultra violet) varnish is applied after printing, either as an overall finish to give a high-gloss finish, or applied as a 'spot' varnish to certain previously printed images.

VEGETABLE-BASED INKS:
Inks derived from vegetable oils instead of petroleum products, thus being easier on the environment.

VIRGIN FIBRE:
Fibre produced for the first time from wood.

WEB PRESS:
A printing press that prints on rolls of paper passed through the press in one continuous piece rather than individual sheets.

CONTACTS:

STUDIO INDEX

Tangent Graphic
Glasgow, United Kingdom
www.tangentgraphic.co.uk
page: 144

The Luxury of Protest
London, United Kingdom
www.theluxuryofprotest.com
page: 28

This is Real Art
London, United Kingdom
www.thisisrealart.com
pages: 170, 184

THIS IS Studio
London, United Kingdom
www.thisisstudio.co.uk
pages: 60, 62, 98

Toby Edwards
Nottingham, United Kingdom
www.tobyedwards.co.uk
page: 56

unfolded
Zürich, Switzerland
http://unfolded.ch
pages: 27, 32, 72,
156, 158

Via Grafik
Wiesbaden, Germany
www.vgrfk.com
page: 153

vijf890 ontwerpers
Schiedam, the Netherlands
www.vijf890.nl
page: 102

Visual Think
Salt Lake City, Utah, USA
In partnership with the University
of Utah graphic design students
www.carolsogard.blogspot.com
page: 48

Webb & Webb
London, United Kingdom
www.webbandwebb.co.uk
page: 122

Wire
London, United Kingdom
www.wiredesign.com
pages: 115, 132, 138

Worldstudio
New York, USA
www.worldstudioinc.com
page: 152

NOTES:

ACKNOWLEDGMENTS

THANK YOU:

Many thanks to all the designers who submitted work for inclusion in *Common Interest: Documents*.

Credits are due to **Jere Salonen** who took the folding format photos for the Introduction chapter, and to Studio EMMI's editorial consultant, **Henrietta Thompson**.

Thank you for the whole team at Index Book.

SPECIAL THANKS:

I want to thank Elsa, Jere, Äiti and Isi for the lifelong support.

This book is for Ramon Marin. Thank you for all you are.